Michael Gibson

ODILON REDON

1840–1916

The Prince of Dreams

TASCHEN

KÖLN LISBOA LONDON NEW YORK OSAKA PARIS

FRONT COVER:
The Chariot of Apollo, 1905–1914
Le Char d'Apollon
Oil embellished with pastel on canvas, 91.5 x 77 cm
Paris, Musée d'Orsay

PAGE 1:
Mask, c. 1910
Masque
Indian ink
Private Collection

PAGE 2:
Redon, c. 1910
Photograph

BACK COVER:
Redon in 1880

BELOW:
The Heart Has Its Reasons, c. 1870
Le cœur a ses raisons
Pen, ink and lead pencil on tracing paper, 15 x 15 cm
New York, The Ian Woodner Family Collection

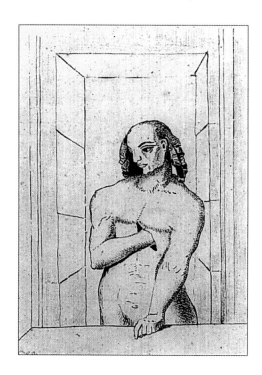

© 1996 Benedikt Taschen Verlag GmbH
Hohenzollernring 53, D–50672 Köln
© 1995 VG Bild-Kunst, Bonn, for Edouard Vuillard
Conception: Gilles Néret, Paris
English text edited by Chris Miller, Oxford
Cover: Angelika Muthesius, Cologne / Mark Thomson, London

Printed in Germany
ISBN 3-8228-8642-4

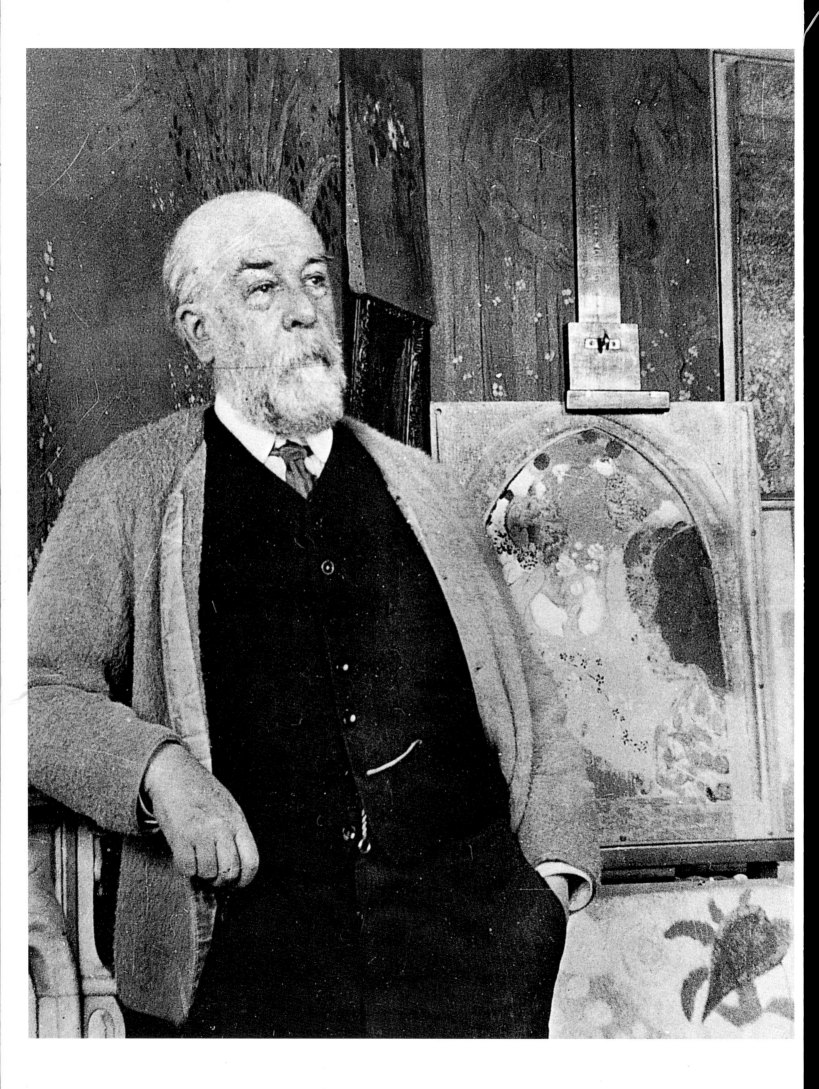

Contents

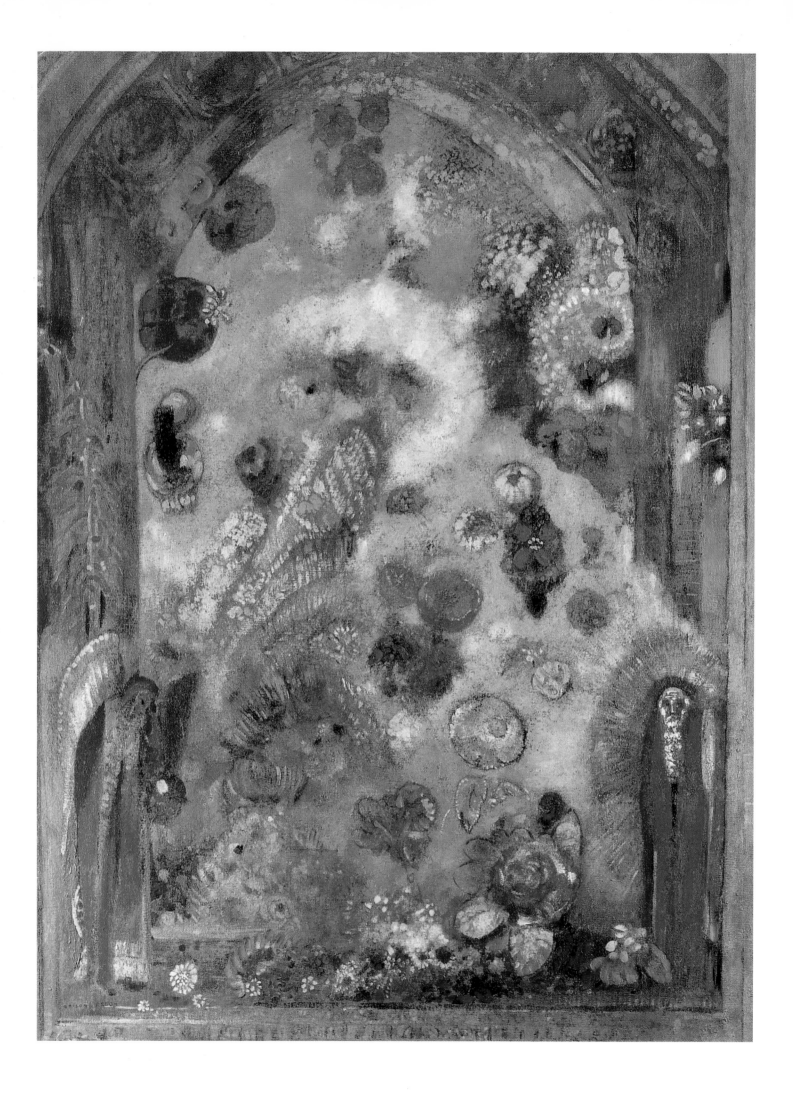

Clouds, Wonderful Clouds...

As for myself, I habitually avert my mind from my painful genesis. Too weak for the struggle or perhaps disdainful of it, I waited; I put forth, as I could, and when circumstances permitted, works which were loved by a small circle around me... It is they which cleared a way for me and which tell my story. I have reason to believe that the most recent will speak of the joy that makes restitution for bad beginnings.

Odilon Redon in 1912 (*To Oneself*)

Profile in an Arch, c. 1905
Profil dans une ogive
Pastel, 63 x 53 cm
Bordeaux, Musée des Beaux-Arts

The name of Odilon Redon (1840–1916) brings to mind a mysterious œuvre illumined by colours of strange intensity. There are luminous pastels in which the red of a poppy singled out amidst a bouquet all but eclipses the frame; the shimmering surface of *Homage to Leonardo da Vinci* (ill. p. 10) with its semblance of masterful improvisation, and the radiance of the series of *Stained-glass Windows* (ill. p. 9) in which dazzling colour alone evokes the luminosity of a cathedral window. Redon's art has a delightful, musical quality whose most perfect expression is the large decorative panels he created for the houses of various friends, along with certain of his later works – *The Buddha* (1905–1910, ill. p. 10); *The Birth of Venus* (ill. pp. 14–16) or the simple *Seashell* (ill. p. 15), the latter of which was painted in 1912 for the pleasure of the artist's creole wife, who collected such things.

That a large part of Redon's works are in black and white – charcoal drawings and lithographs teeming with sombre visions, some strange, some terrifying, that seem to have emerged from a commonwealth of dreams – is well enough known. But it may come as a surprise to discover that Redon's work falls into two distinct periods. Until he was fifty, darkness and the nocturnal were Redon's almost unrelieved obsession. The dazzling colours that we associate with his name came, unpredictably but irrevocably, at an age when most artists have already displayed the full range of their abilities and achieved much of their finest work. Colour transfigured the mood of his art and lit up the last twenty-six years of his life with joy.

"I have made an art according to myself." This strange, eloquent remark stands at the threshold of Odilon Redon's writings, which were collected and published by his son Arï under the title *A Soi-même* (To Oneself). For those who know his work, the expression illuminates an essential aspect of this purest and most singular of artists. "I have done so," he continues, "eyes open to the marvels of the visible world and, whatever anyone says, constantly concerned to obey the laws of nature and life."

Odilon Redon is a paradigm of the pure artist. For an artist is not, in essence, a virtuoso. An œuvre can hold our attention and move us only to the extent that we perceive in it a response to a spiritual and emotional necessity. The artist seeks to compensate for some deep-rooted sense of lack

This monograph does not always give the dates of Redon's works, as the artist rarely dated his work. He did keep a register in which he noted precise details of works, buyers and prices, but this is under seal until 2002. Our captions follow Volumes I and II of the Catalogue raisonné published by the Wildenstein Institute in 1992 and 1994, edited by Alec Wildenstein.

PAGE 6:
Stained-glass Window or ***Allegory***, c. 1908
Le Vitrail, dit aussi L'Allégorie
Oil on canvas, 81 x 61 cm
New York, The Ian Woodner Familiy Collection

PAGE 9:
Stained-Glass Window, c. 1904
Le Grand Vitrail
Charcoal and pastel, 87 x 68 cm
Paris, Musée d'Orsay
Redon has here contrasted his habitual sombre tones with dazzling colours that admirably evoke the luminosity of stained-glass.

RIGHT:
The Golden Cell or ***The Blue Profile***, 1892
La Cellule d'or, dit aussi Le Profil bleu
Oil, gold and pastel on paper
London, The British Museum
The gold and blue in this picture are inspired by the Primitive school. Leo Tolstoy, disconcerted, wrote that "one of them, whose name was something like Redon, had painted a profile in blue!"

BOTTOM:
Stained-glass Window
Le Vitrail
Oil on canvas, 69 x 51 cm
Private collection

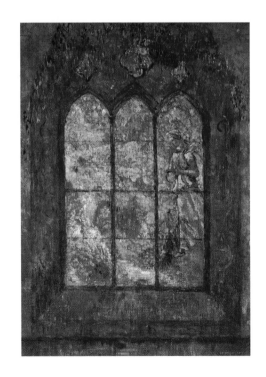

which causes acute discomfort. Impelled by an existential unease whose nature is not our concern, he or she surpasses others despite feeling bereft of something which they apparently take for granted. "What distinguishes the artist from the dilettante", Redon observed, "is simply the pain experienced by the former. The dilettante looks to art only for his pleasure."

Odilon's father, Bertrand Redon (1798/99–1874), a native of Bordeaux, went to Louisiana as a young man to seek his fortune: "He was a settler, he owned negroes", says Redon, with his habitual concision. "He seemed to me an imperious being, independent in character, even harsh, before whom I have always trembled." It was nevertheless this man who first steered his child towards the realms of the imaginary and indeterminate so characteristic of Redon's work: "My father often used to say to me: 'Look at those clouds, can you see the changing shapes in them?' And then he would show me strange beings, fabulous and supernatural visions." Here, as so often in his writings, the artist reveals himself with endearing candour. His father's affection for Redon lay hidden beneath a rough exterior, as an 1868 letter from him testifies. It closes: "Your father who loves you always, though he does not show it."

Leonardo da Vinci: *Madonna with Child and
Saint Anne*, 1510
Oil on wood, 168 x 130 cm
Paris, Musée du Louvre

writes, amassed "a rich sediment of human soul…, full of history and time,
like a spirit of things, a spirit of legend too."

In this region of silence, the pine trees impressed themselves on his mem-
ory with their "constant sad susurration". He was fascinated by the shep-
herds who "with high stilts trace their strange outline on the sky… The hu-
manity one meets there seems prostrate, lifeless and dissolute, the eyes of
each cast down, as though resigning both themselves and the place." The de-
scription is empirical, but we hear in it the young Redon's sensitive and mel-
ancholy disposition. The pitiful faces of some of his drawings also derive
from this period. Though he loved the place deeply in later years, he wrote
that Peyrelebade had "had a great influence on my childhood and my youth,
and even on my life." There he spent the first eleven years of his life, left to
his own devices in the absence of his parents and siblings (he had a younger
sister and three brothers).

His recollections suggest that his time was spent in daydreams: "One
travelled by stagecoach and even by ox-cart, a monotonous locomotion,
peaceful, and numbingly slow", which allowed him to observe the

Portrait of Mme Arthur Fontaine, 1901
Portrait de Mme Arthur Fontaine
Oil on canvas, 72.4 x 57.2 cm
New York, The Metropolitan Museum of Art

PAGE 13:
Eve or *Nude with Blue Scarf*
Eve, dit aussi Nu à l'écharpe bleue
Pastel, 44 x 37 cm
Philadelphia, The Philadelphia Museum of Art

unfolding of the landscape "in a fixed state of contemplation and suggestion."

This self-portrait, a mixture of light and dark touches, is echoed by similar observations: "I see myself in those days as sad and weak." A sickly child, "weak-minded" in his own words, Redon was sent to school only when he returned to his parents. He seems to have projected his gloom and enthusiasm onto the clouds sailing in from the Atlantic in endless convoys: "Later, long afterwards … I spent hours, or rather whole days, stretched out on the grass, in empty stretches of countryside, watching the clouds pass, following with infinite pleasure the fairytale brilliance of their incessant changes."

Such a childhood, spent in solitude like that of an orphan up to the age of

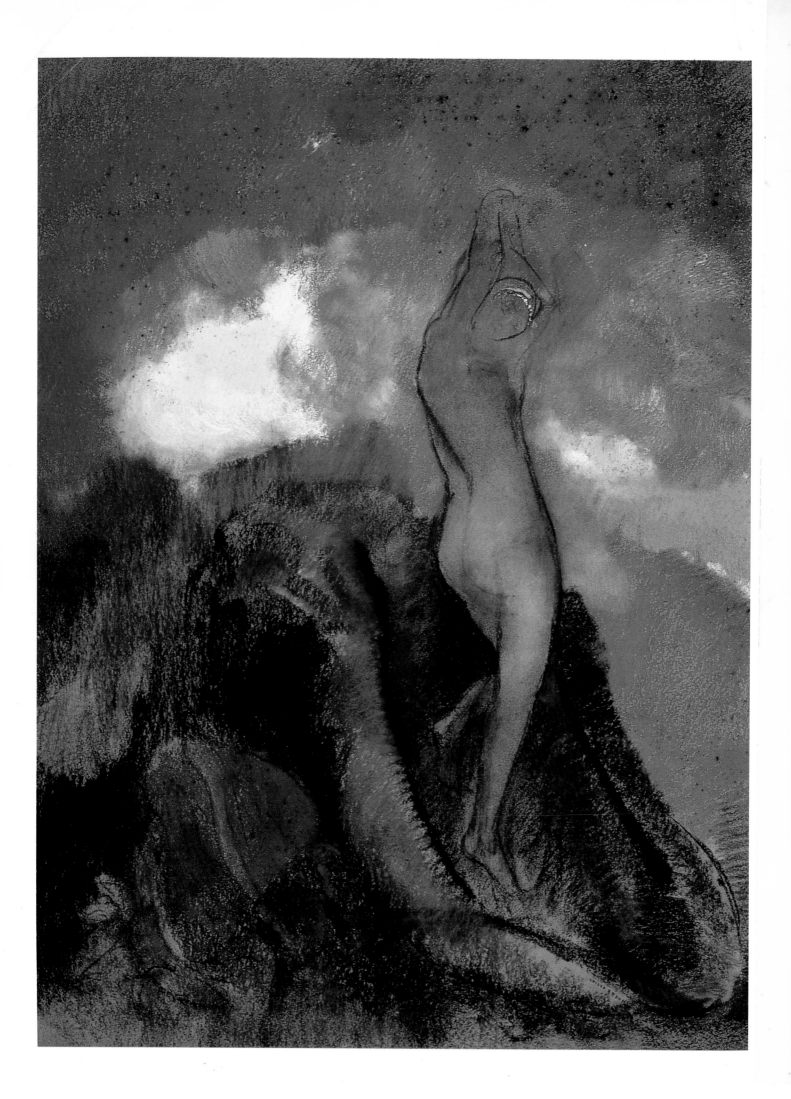

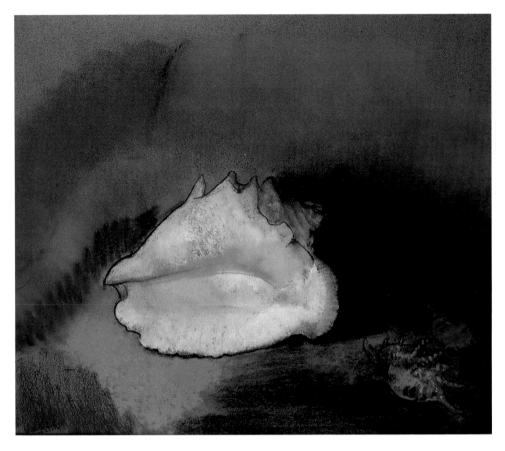

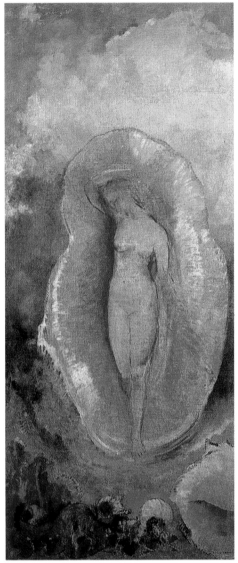

The Birth of Venus, 1912
La Naissance de Vénus
Oil on canvas, 143.4 x 62.2 cm
Private collection

eleven, favoured a melancholy disposition. Indeed, it might have caused lasting depression. But his inner resources were also quick to emerge. Frail and gentle as he was, he did what many children of that age do, even under more brutal circumstances; he assumed that 'this was the way things were' and uncomplainingly put up with his fate.

The sombre and highly imaginative quality of his first period has prompted an unfortunate comparison with Francisco José de Goya (1746–1828). Redon himself produced a series of lithographs entitled *Homage to Goya*, which have been thought to justify the comparison. Yet the differences between the raging vitality of the Spanish artist, whose every line seems to excoriate some monstrous trait of human nature, and the gentle dreams of Redon are clear enough. Redon's character, his contemplative melancholy, inhibited his development for a long time. His sensitivity too, the very foundation of his art, could, when the artist's critical sense was wanting, lead to sentimentality – rather as the tremendous energy of a Pablo Picasso (1881–1973) could, at the other end of the spectrum, sink into brutality.

"One must be modest", Redon declared, "in putting before the eyes of the public the whole of one's production – always uneven, good or bad some years, with good days and bad days." The *Homage* does indeed acknowledge a debt to Goya. But the debt was of neither style nor content; it was the revelation that art need not be exiled among the things of the world, but was free to explore the inner realms. In this respect Rembrandt, too, was a precursor: "The day on which Rembrandt advised his students against travelling and above all against the voyage to Italy, on that day, I believe, he became the precursor of all deeply inward art." Hence his unambiguous conclusion: "Art is a flower which blossoms freely, to the exclusion of all rules; in my view, it leaves in sad disarray the microscopic analyses of the 'aestheticians' who seek to explain it."

The Birth of Venus
La Naissance de Vénus
Oil on canvas, 21.6 x 16.5 cm
Private collection

Orpheus, 1900
Orphée
Oil on canvas, 73.5 x 54 cm
New York, The Ian Woodner Family
Collection

Redon was long in finding himself, and it seems that his maturity was prompted by the crucial emotional experiences of the second half of his life. "Within each of us at birth", he said, "is a potential Other maintained, cultivated and saved by our will – or not saved." His own qualities are incomparable: his exceptional mastery of black and white, his coruscating colours, and above all the moving transformation in his work during the 1890s. Late in life, remembering a great friend and mentor of his late teens, the botanist Armand Clavaud, he observed: "I wish I could now put before him my resolved thought, more certain than it was before. He knew in me only the sensitivity of a wavering and contemplative being, entirely wrapped up in

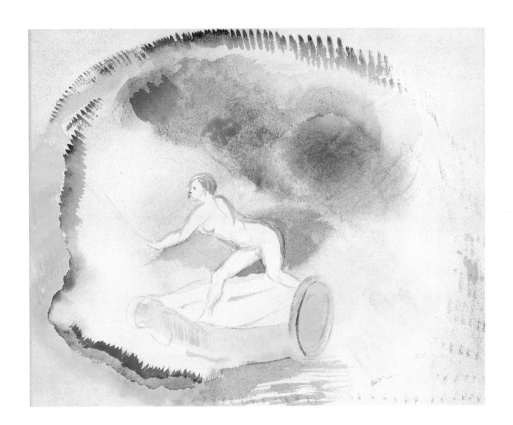

Naked Woman on a Chariot
Femme nue sur un char
Watercolour, 20.3 x 26.7 cm
Private collection

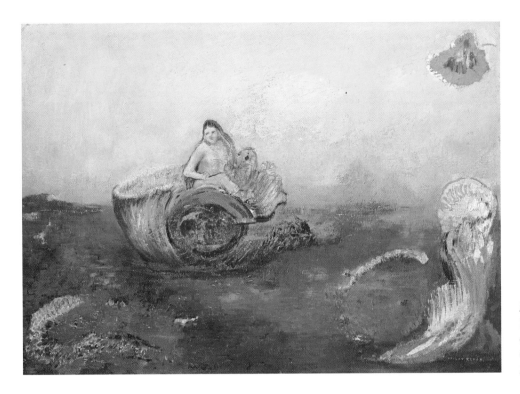

Marine Divinity or *The Birth of Venus*
Divinité marine, dit aussi La Naissance
de Vénus
Oil on canvas, 33 x 46 cm
Japan, Private collection

his dreams." It was Clavaud who led him to the literature of his day; it was
through Clavaud's microscope that Redon first discovered the world, then
all but unknown, of the infinitely small.

When he returned to his family after eleven years at Peyrelebade, Redon
was promptly enrolled as a day student in a boarding school in Bordeaux:
"I recall only being late for classes, putting so much effort into work that
it pained me. How often I cried over my books…"

On its return from America the family had settled in the Saint-Seurin quar-
ter of Bordeaux. The church of Saint-Seurin, with its hybrid architecture,
was the focus of religious practices that were part of the urban folklore.

Robert Coustet (Catalogue Odilon Redon, 1985), mentions the low, heavy vaults of the narthex, the capitals decorated with monstrous figures, the ample nave, the chapels sunk in shadow, and most important of all, the crypt. "One descended a narrow staircase, its steps well-worn, to reach the underground chapel. Two rows of short pillars, topped with rough-hewn capitals, upheld the vaults beneath which rested the sarcophagus of Saint Fort. Each year, in spring (16 May), pious mothers led their children to the saint's tomb, so that he might impart to them a share of his strength and guarantee their health. It seems highly unlikely that young Odilon, who made his first communion in Saint-Seurin, never ventured into the crypt…". Redon himself remembers being a "radiant visitor of churches" at that time.

The boy's first communion evoked other associations too. At the age of sixty, Redon, a man of exquisite reserve, confided to his diary: "I love little

Portrait of Arï Redon, 1898
Portrait d'Arï Redon
Pastel on board, 45.5 x 31.5 cm
Chicago, The Art Institute of Chicago

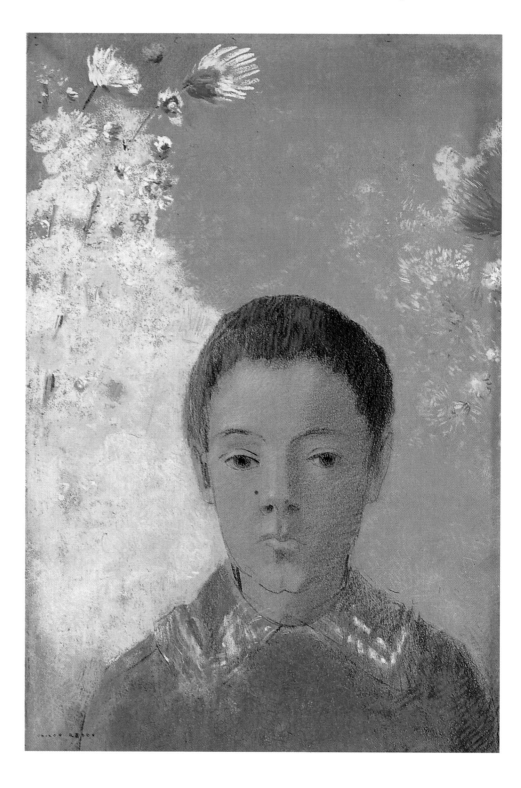

PAGE 19:
Portrait of Mademoiselle Jeanne Roberte de Domecy, 1905
Portrait de Mademoiselle Jeanne Roberte de Domecy
Charcoal, 50 x 37 cm
New York, Private collection
This portrait was made at the time when Redon was painting the large decorative panels for the house of his friends at Domecy.

18

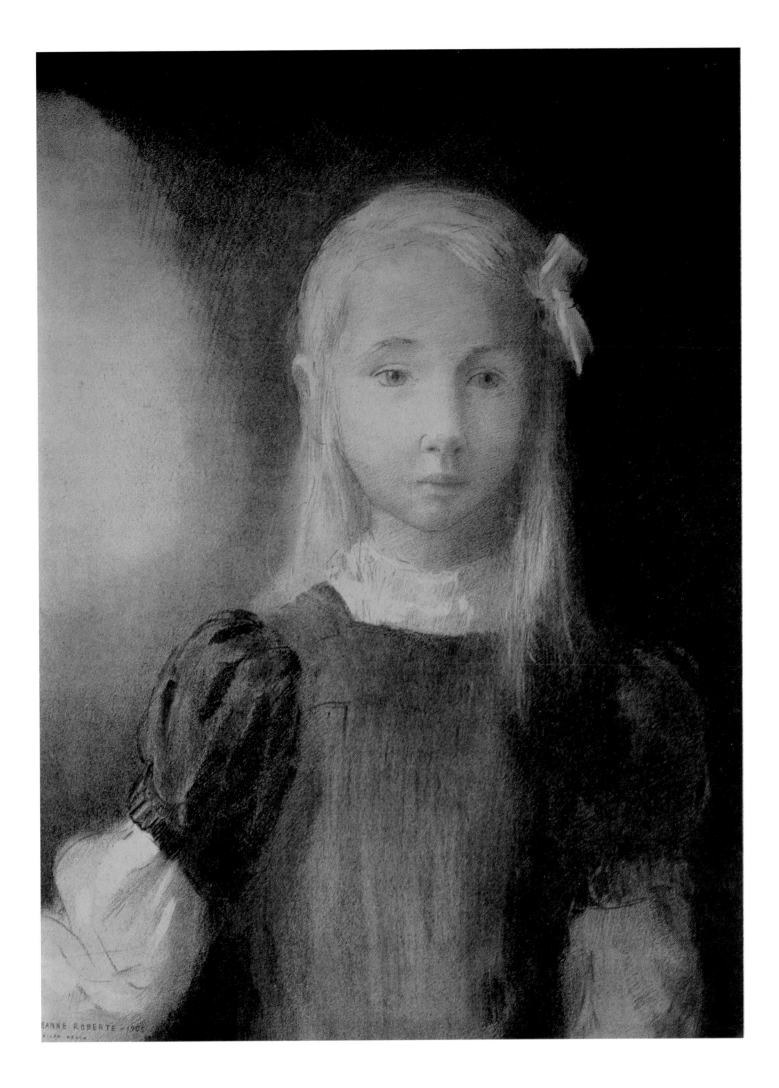

PAGE 20:
Joan of Arc, c. 1900
Jeanne d'Arc
Pastel, 52 x 27.5 cm
Paris, Musée d'Orsay

LEFT:
The Grace or **The Blessing**
Le Bénédicité, dit aussi La Bénédiction
Watercolour and black chalk, 25.5 x 18.2 cm
New York, The Ian Woodner Family
Collection

BOTTOM:
Armour, 1891
L'Armure
Charcoal and conté, 50.7 x 36.8 cm
New York, The Metropolitan Museum of Art
In addition to the sometimes insipid imaginary
heads that Redon painted, there were others,
like this helmeted head bristling with spines,
which seems to belong to a world of dreams.
What does it mean? Interpretation is here in
the eye of the beholder.

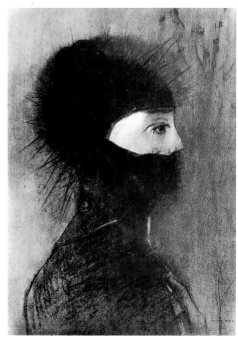

girls; in each I see woman without finding a woman, and that is exquisite…
When I was a child I remember how impressed I was by them. The first time
was in the garden of the house where I was born (in Bordeaux, *allées
d'Amour*). She was blonde, with large eyes, and her hair fell in long curls on
the muslin dress which brushed against me. A shiver went through me. I was
twelve, I was about to make my first communion…".

Redon began drawing when a small boy. He was precocious; he won a
prize for drawing at the age of eleven, "even before [he] could read". When
he was about fifteen he was allowed to take drawing lessons with the
painter Stanislas Gorin on his days out from school. "He was a distin-
guished water-colourist and very much an artist. His first words – I will
always remember them – were to advise me that I too was an artist and
should never allow myself so much as a single pencil *trait* in which my
sensibility and mind had no part." Master and pupil spent these days in the

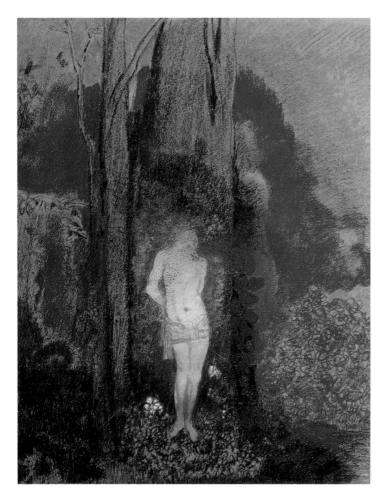

Saint Sebastian
Saint Sébastien
Watercolour, 25 x 17 cm
Private collection

Saint Sebastian, c. 1913
Saint Sébastien
Pastel, 66.5 x 53.5 cm
Takasaki, Gunma, Museum of Modern Art

artist's studio, which stood in the midst of a garden overflowing with flowers, working under "a large bay window that let in the light from the edge of a small wood."

Gorin took the young Redon to exhibitions, giving his comments on the works of Jean Francois Millet (1814–1875), Camille Corot (1796–1875), Eugène Delacroix (1798–1863) and the young Gustave Moreau (1826–1898), again and again stimulating Redon's enthusiasm. "It was with him that I learned the essential law of creation… that art-organism which cannot be learned by rules or formulas…"

When Redon was seventeen, his parents demanded that he should study architecture. He spent some time working for an architect, and did "much descriptive geometry, piles of working drawings" before taking the entrance examination of the "School of so-called Fine Arts", where he failed the oral examination. This work proved useful in the course of time: "I found it easier to place the probable and the improbable side by side, and could give a visual logic to the elements of the imagination that I glimpsed." Traces of this training perhaps appear in the superb treatment of the sphere in the two versions of *The Cannonball* (1878).

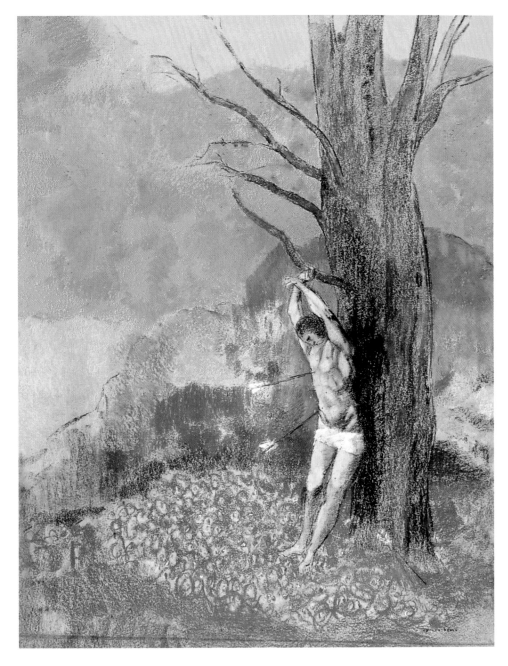

Saint Sebastian, c 1910
Saint Sébastien
Pastel, 69 x 52.5 cm
Bordeaux, Musée des Beaux-Arts
Saint Sebastian, a conventional figure of martyrdom, was bound to a tree and riddled with arrows by the archers of his own regiment.

At the age of twenty-four, Redon was admitted to the class of the academic painter Léon Gérôme (1824–1904) at the "School of so-called Fine Arts" (Redon reiterates this expression) in Paris. With painful modesty, the young man tried to conform: "I was tortured by the teacher... He was clearly trying to inculcate in me his own vision... or to put me off art itself... So vehement were his corrections that a stir went through my classmates whenever he came near my easel." Young Redon saw in reality forms palpitating and uncertain; Gérôme wanted it given definition by an outline. For Redon, this was intolerable: "I feel only the shadows, the apparent depths; all outline is indubitably an abstraction." Redon's perceptive account of this episode led him to a very modern conclusion: "No-one makes the art that they want to", he notes. The work is made "according to its own laws".

Much later, analysing the effect of his own work, Redon formulated it precisely: "My drawings are not self-defining; they inspire. They determine nothing. Like music, they place us in the ambiguous world of the indeterminate." This priority given to the indeterminate, used to lure the spectator into the aesthetic interaction, tends to render a title superfluous. "The title is

PAGE 24:
Saint John the Baptist or *The Blue Tunic*, 1892
Saint Jean-Baptiste, dit aussi La Tunique bleue
Pastel, 42.5 x 29 cm
New York, Private collection

PAGE 25:
Evocation, c. 1893
Evocation
Charcoal embellished with pastel
Chicago, The Art Institute of Chicago
This beautiful haloed head dwells on a luminous embryonic form born from the darkness of space and perhaps symbolic of origins in general.

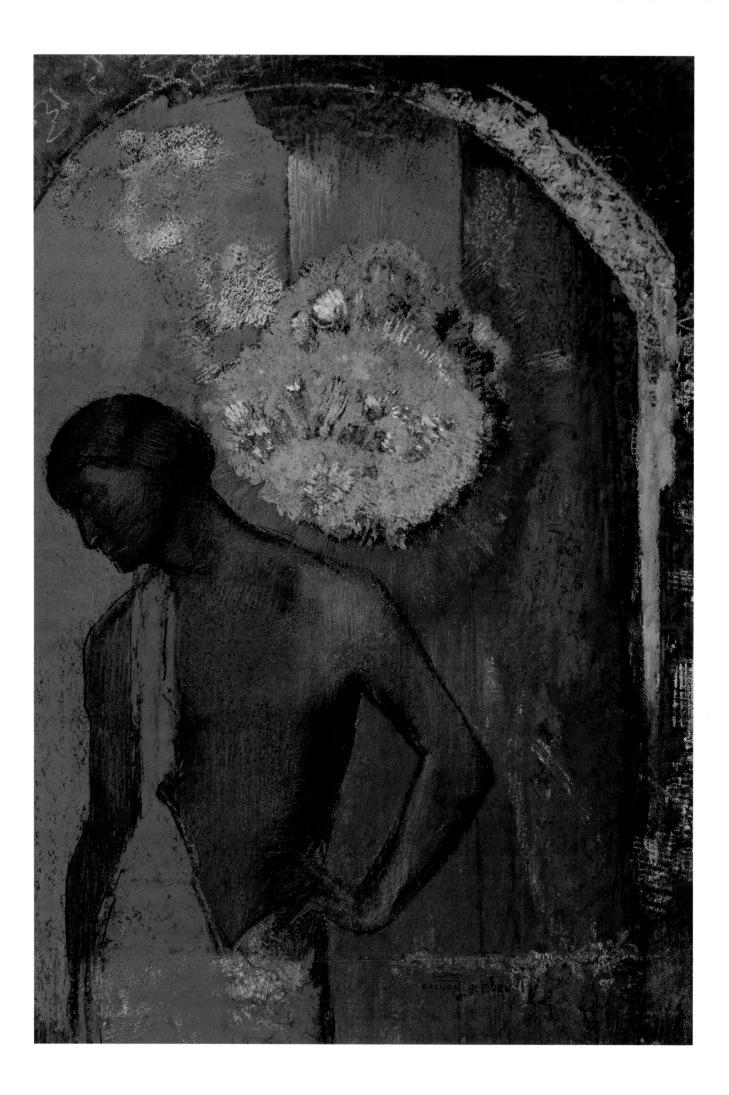

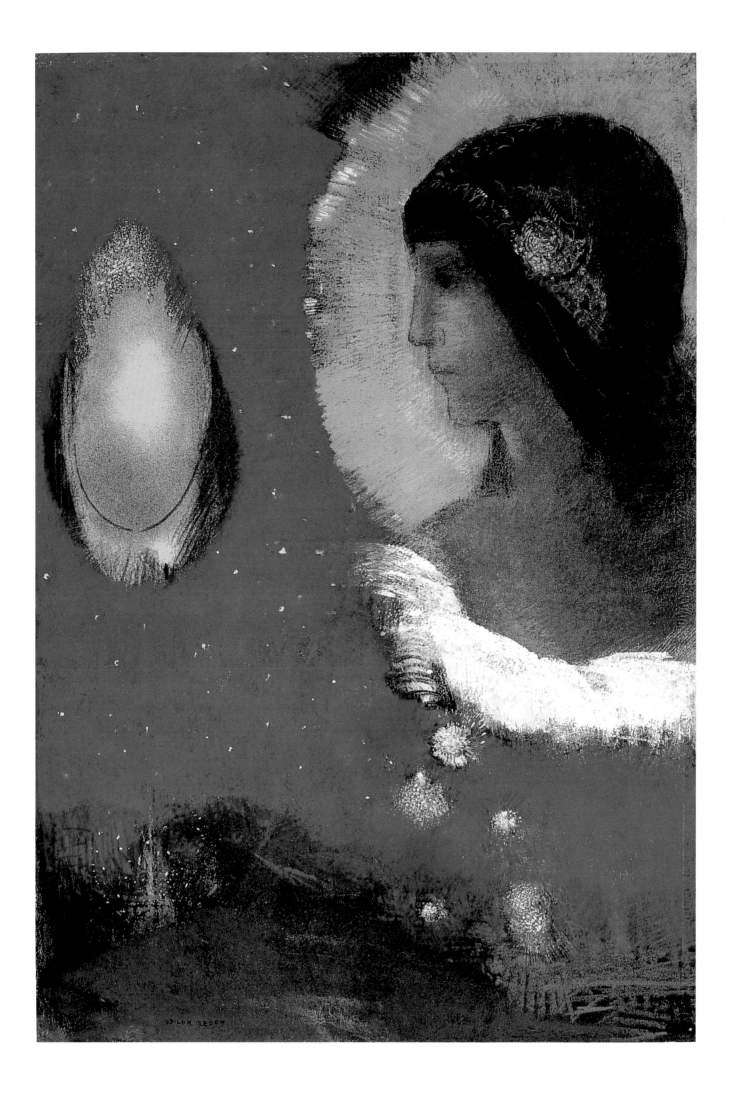

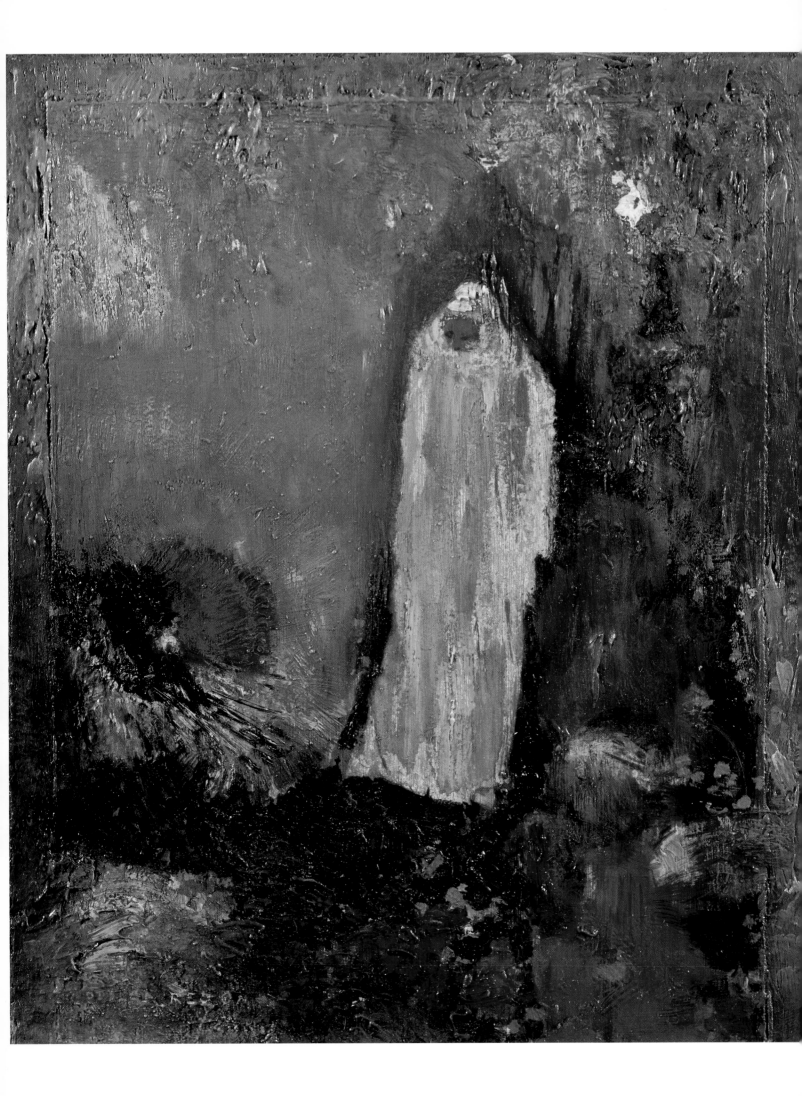

Silence or *The Black Sun*
Le Silence, dit aussi Le Soleil noir
Oil on board, 32 x 23.5 cm
Private collection
Redon liked to depict enigmatic emblems of
unspecified spiritual forces in his indistinct
forms. According to the Wildenstein Institute
catalogue, this little oil on canvas was one of
the artist's favourite works, and for a long
time he kept it on his desk.

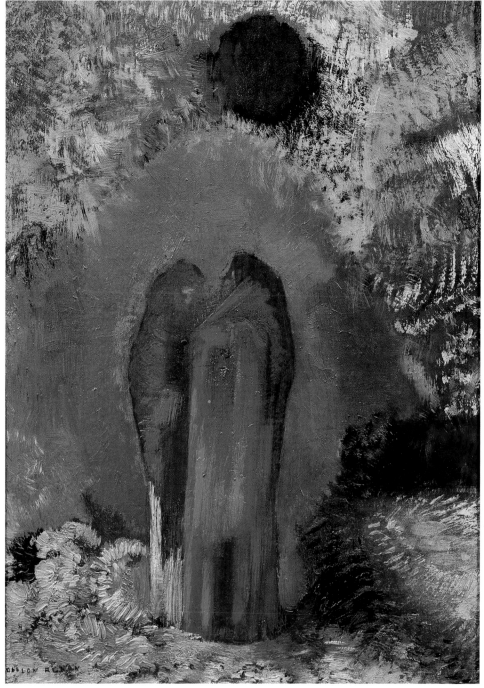

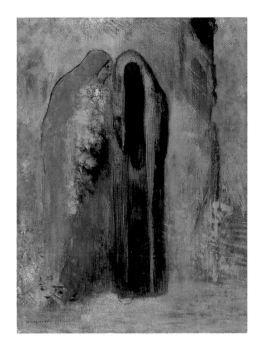

Two Veiled Personages
Deux personnages voilés
Oil on wood-backed canvas, 35 x 26.5 cm
Private collection

Imaginary Figure or *The Resurrection of
Lazarus*
Personnage fantastique, dit aussi La Résur-
rection de Lazare
Oil on wood, 22.6 x 18.8 cm
Osaka, Art Salon Takahata

justified only when it is vague, indeterminate; when it aspires, confusedly, to
the ambiguous."

Back in Bordeaux in 1865, having suffered a whole year of the implac-
able Gérôme, Redon met a soul as pure as his own in Rodolphe Bresdin
(1825–1885). The work of this romantic engraver, whom Redon described
as "both commoner and aristocrat", was akin to that of Albrecht Altdorfer
(c. 1480–1538) or Matthias Grünewald (c. 1470/80–1528). At the time, Bres-
din was living in one of the city's "half-built areas", the rue Fosse-aux-
Lions, which has since been demolished. Bresdin, who lived a life of almost
complete destitution, pointed out the irony of his address (Lion-Pit Street)
with rueful humour.

Bresdin taught Redon etching and lithography, "with the greatest concern
for my independence." In fact, Redon signed his first etching (*The Ford*,
1865, p. 46), "O. Redon, pupil of Bresdin." But Bresdin also opened his eyes

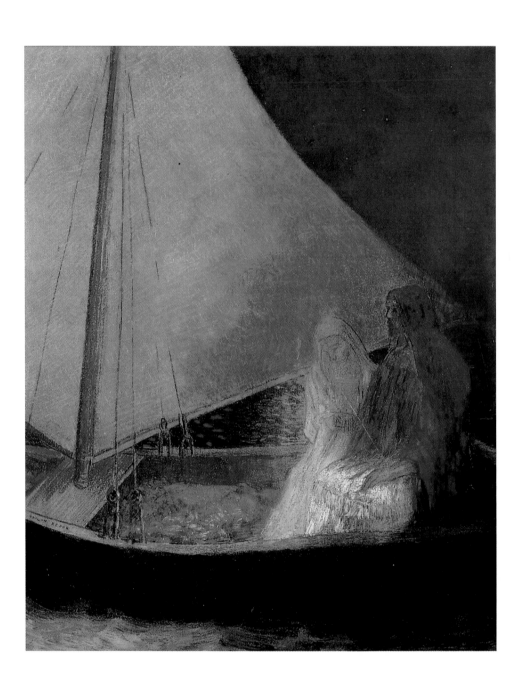

Two Lovers in a Boat, 1902
Deux amants dans une barque
Pastel, 61 x 51 cm
New York, The Ian Woodner Family
Collection

to the world of the imagination: "Once he told me with gentle authority: 'Look at this chimney flue. What does it say to you? To me it recounts a legend. If you have the strength to observe and understand it, imagine the most strange, the most bizarre subject; if it is based on and remains within this simple section of wall, your dream will be alive. That is art.'"

The preparations necessary for an artistic career were, by now, complete. The young man had acquired his craft, his imagination had been stimulated. Yet the Redon that interests us today was still a long way ahead. The young artist was now painting numerous small landscapes; he kept almost all of them, thanks to which the Louvre, which received a considerable donation from Madame Arï Redon in 1982, now owns forty-six. They are modest in ambition, but the intensity of the sunlight striking here a tree, there a piece of wall, seems to herald the interaction of dark and light that is so apparent in the second phase of his production.

Redon, from the outset, devoted much time to the study of the kind of subject that attracts draftsmen: faces, bodies, horses, trees, rocks, houses, landscapes, flowers and leaves. And the years went by. In 1868, his *Roland at Roncevaux* was accepted by the Bordeaux Salon. In 1870, when Prussia invaded France, the young man was involved "with much emotion in the har-

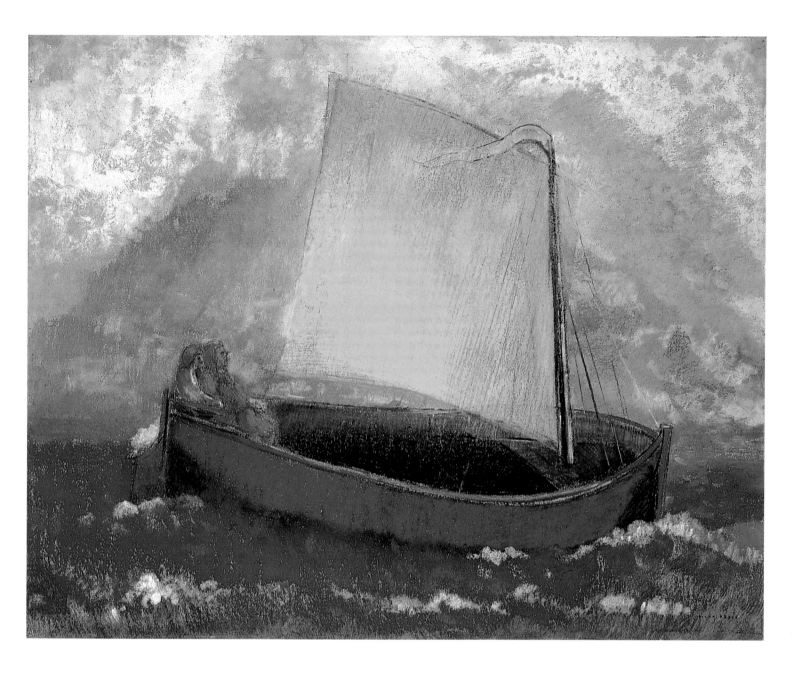

rowing turmoils of a battle on the Loire, near Tours: a senseless day that disturbed me deeply, leaving me with a sense of pity and pain at an hour of such inexorable ruthlessness, as though I had subjected myself to the barbarity of a different humankind." At about the same time, Bresdin and Gustave Courbet (1819–1877) played an active part in the Commune. As a result of this, Bresdin took the precaution of moving to Canada in 1872. He returned to France in 1877 and found himself reduced to sweeping streets for a living. Towards the end of his life, he was official road-mender at the Arc de Triomphe.

It was on his return from the Prussian campaign that Redon at last felt confirmed in his artistic calling: "The merest sketch or scribble... in my portfolio took on a new sense. And that was the true date of my determination" (*Letter to E. Picard*, Mellerio, 1913). The interruption to his routine and the brief confrontation with war and death perhaps played a part in this decision.

Redon began using black consistently in 1875. Earlier in the decade, a variety of works touching upon the horrible, the funereal or the fantastic anticipate the later work. But Redon's dates of execution are never easy to establish. An artist outside time, he rarely dated his works. The artist's father had died in 1874 and the family found itself in financial straits. Was Bertrand

The Mystic Boat, c. 1890–1895
La barque mystique
Pastel, 51 x 63.5 cm
New York, The Ian Woodner Family Collection
For Redon, the birth and survival of his second child came as a late confirmation of the reality of his links with the world. Now, in his happiness, he could hoist the dazzling sail of his "mystic boat" and set sail for the distant glimmer of paradise.

Apparition
Apparition
Oil on wood, 67 x 40 cm
New York, The Ian Woodner Family
Collection

Redon's death experienced as a liberation by his son – who was, by then, already thirty-four?

In 1879 he published a first sequence of lithographs, *In Dream*, which were greeted with enthusiasm by the critic and novelist Joris-Karl Huysmans (1848–1907).

On the first of May, 1880, Redon married Camille Falte, a young creole woman from Bourbon Island (later Réunion). She was a lively, resolute woman who thereafter handled all the artist's business with dealers and the press. Redon had just turned forty, and devoted that entire decade to what he termed *Les Noirs* ('the black works'). "In Madame Redon," he later wrote to André Mellerio, his first biographer, "I found something like a sacred thread, the Fate of my life, who helped me to survive the most tragic but secret moments of my family drama… I believe the yes I uttered on the day of our union, was the expression of the most complete and unadulterated certainty I have ever experienced. A certainty more complete even than my vocation." (Lettres, p. 37)

Six years later, on May 11th 1886, Jean, their first child was born. He died six months later, in the autumn of the same year. These were probably the "tragic but secret moments of my family drama" that the artist had in mind. "The affection of the father", Redon observed some months later, "is the very creation of his child: it is his prize, his conquest, his triumph. And this infinite attachment – which is a certainty – is a mystery when broken." Joris-Karl Huysmans was among those who gathered round in time of sorrow: "Our dear Huysmans was full of compassion", Redon later wrote. "Though he claimed to hate children, with my wife and I, he kept watch throughout the night at the side of the child we had lost. He said, as though to justify himself: 'Your children are not like those of other people'" (Léon Deffoux, J.K. Huysmans sous divers aspects, Brussels 1942, pp. 82–83, in *Catalogue de la Donation Arï et Suzanne Redon*, p. 63).

Arï, their second child, was born two and a half years later, on 30 April 1889. "Everything is going well at last", Redon announced, in June of that year, in a letter to his mother. "So well, in fact, that I am afraid. It seems too beautiful." And it was at the birth of Arï, or shortly thereafter, that colour finally entered the painter's work. Odilon Redon was then approaching fifty. "Art", he observed, "obeys secret laws and also has a share in the events of life."

In 1897, as a result of a disagreement between the Redon brothers, the family estate at Peyrelebade was put up for sale. Redon went down for a final stay which lasted eight months. He returned to those parts seventeen years later, two years before his death: "Under a lovely light and a beautiful sun," he wrote to his friend Doctor Sabouraud (1864–1938), "I travelled to the Médoc during the *vendange*. I am glad I did, for now that I am there no longer, I understand the fatal origins of the mournful art I produced there…".

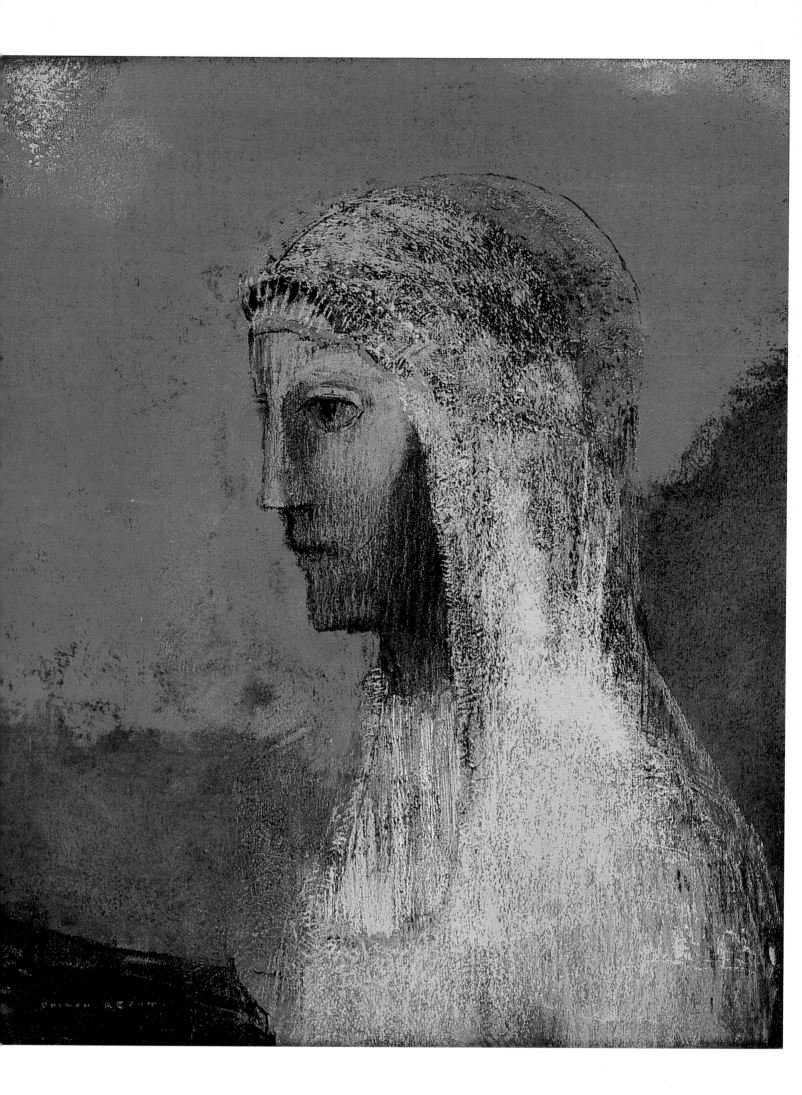

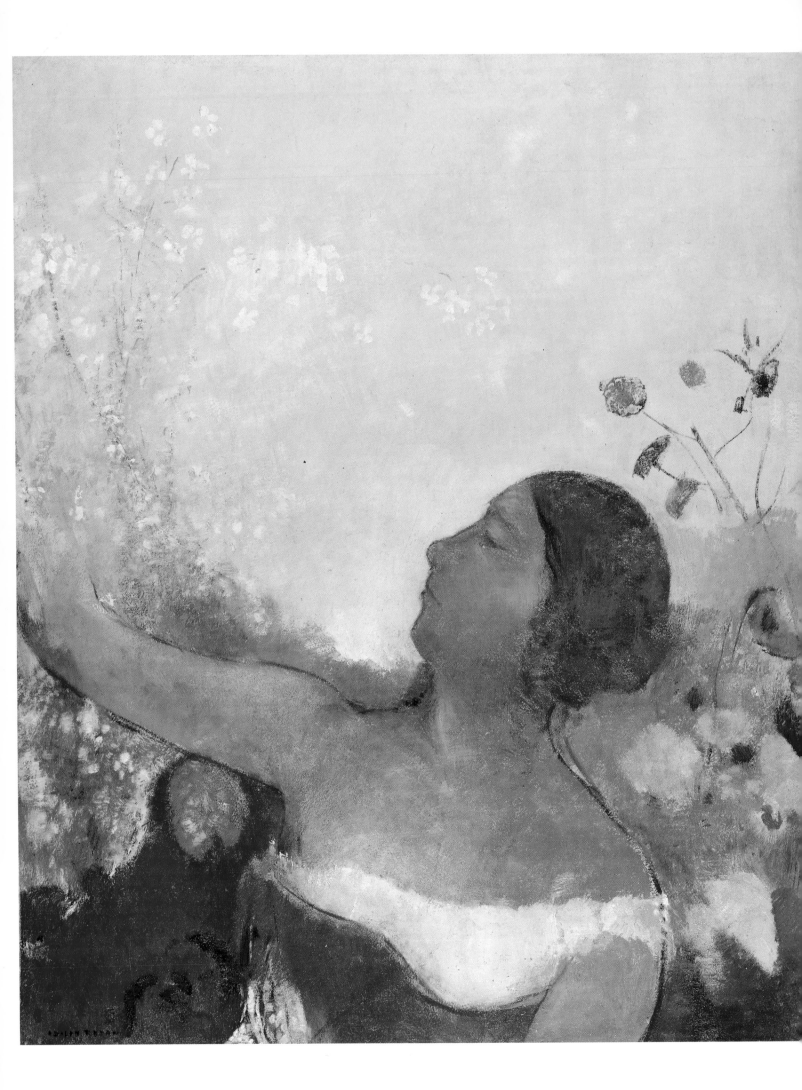

The Artist is an Accident

"The artist … is an accident. Nothing awaits him in the social world. He is born naked on the straw, with no mother to prepare his swaddling clothes. Young or old, he has no sooner offered the rare flower of originality – which is and must be unique – than the perfume of that unknown flower troubles people and everyone turns away from him. Whence, for the artist, a fatal, even tragic isolation."

Odilon Redon wrote these words with his own experience in mind. No doubt he was also thinking of his mother's absence during the early years of his own life. The phrase "with no mother to prepare his swaddling clothes" is the more poignant when we realise this. The primary sense is metaphorical, the second literal and autobiographical – an admission apparent to those who read between the lines. But Redon was also thinking of his friend Bresdin, doomed, for lack of a fortune of his own, to "all the hardships of disenchantment". For it is true that nothing in the social world awaits the artist – whether a relatively well-off Redon or an impoverished Bresdin.

This is hardly a surprise. All institutions, and society as a whole, no matter how efficiently they function, must devote their attention to a limited number of well-defined tasks. That is, after all, the purpose of their existence. They cannot accomplish this without becoming set in their ways, without adopting prejudices and routines essential to the accomplishment of such tasks. The people who run these institutions are inevitably tempted to fit the artist and his work into patterns that they themselves are constantly using. They imagine that art is intended to entertain them, or to serve an ideal (the institutional ideal, of course) or the state, or indeed the market. It is these suppositions that Redon's contemporary, Oscar Wilde (1854–1900), sought to refute with his assertion: "All art is quite useless." These words expressed the unspoken conviction of the philistines of his day but Wilde, the master of paradox, reclaimed them and made of them a proclamation of the unique and incomprehensible importance of art. To which the modest Redon might almost be responding when he writes: "I thought in former days that art was useless; it might perhaps be necessary".

The work of art removes its spectators from the practicality of daily life, transporting them toward dream, doubt and the ill-defined: 'Are you sure things are as you have always supposed?' This is the challenge the work of art presents to both individual and society, like a troubling dream whose memory saps the convictions of the waking dreamer. More than any other major French artist of his day, more even than the actively rebellious Paul Gauguin (1848–1903), Redon matured in silence and seclusion outside the 'social world'. Yet as an artist he stood at the centre of the realm of the imagination, and his artistic daydreams coincided in mysterious ways with the

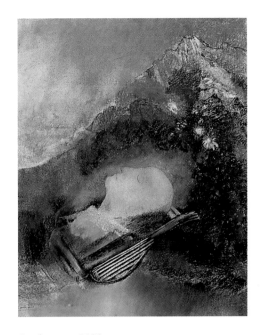

Orpheus, c. 1898
Orphée
Pastel, 69 x 56 cm
Cleveland, The Cleveland Museum of Art
According to the legend, Orpheus was torn apart by the Bacchants. His head, carried off down river on his lyre, continued to sing.

PAGE 32:
The Predestined Child or ***Ophelia***
L'Enfant prédestinée, dit aussi Ophélie
Oil on canvas, 65 x 54 cm
Private Collection

33

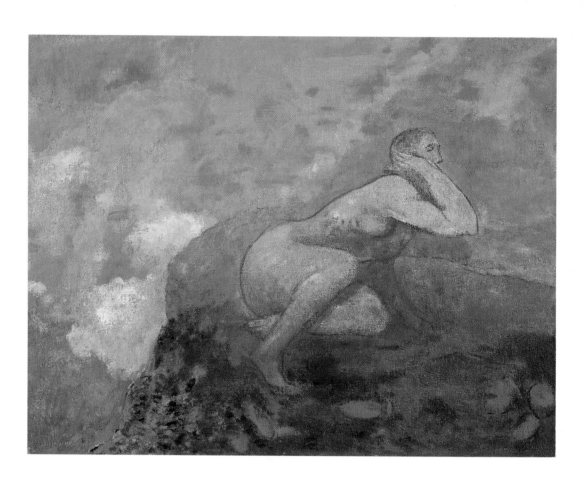

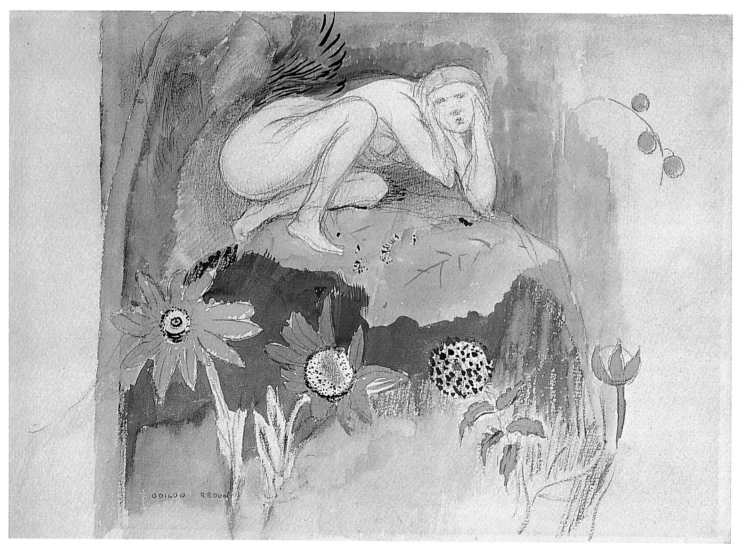

great collective daydream that we call culture, which is endlessly being re-shaped by literature, the arts and music, and which nurtures us all.

At a time when many artists (from Gustave Courbet to Thomas Couture) were executing monumental works, Redon consistently preferred to work on a small scale. He justified his taste and deplored the fact that even the greatest masters sometimes proved guilty of "excessive size in the surface painted or drawn". He criticized Dürer and even Rembrandt (though he admired the latter more than any other artist) for very large format etchings which are "far from the perfection that transpires in plates of normal size." Redon adds: "The most perfect works were produced in a size recommended by taste and reason: but the sizes that a mediocre artist easily lights on seem rather the effect of chance than conscious choice in the works of the most inspired artists." Redon invokes unspecified formal motives for preferring a smaller format, but the question he raises relates to the significance of his entire corpus, and thus invites one to contemplate the significance of scale in painting. All paintings are read as signs. There are discreet signs which establish an immediate and intimate communication. Others, ampler, more emphatic and rhetorical, address society as such. The large-scale work is particularly suited to subjects connected with the fate of society – consider, for instance, Michelangelo's (1475–1564) *Last Judgment*, Delacroix's *Liberty Guiding the People* or even Courbet's *Burial at Ornans*. Such works set out major religious, political or philosophical principles on a declarative, emotional register.

Naked Woman on a Rock
Femme nue au rocher
Oil on canvas, 50 x 64 cm
Japan, Private collection
"Is this woman still Venus or already Andromeda? Naked, hesitant, she seems about to rise – unless she is still chained down."
(A. Lacau St Guily – Wildenstein Institute)

PAGE 34, BOTTOM:
Temptation
Tentation
Watercolour and pencil, 17.7 x 25.1 cm
New York, The Ian Woodner Family Collection

BOTTOM:
Nude, Begonia and Heads, c. 1912
Nu, bégonia et têtes
Watercoloured drawing, 17.6 x 25.2 cm
Switzerland, Private collection
These three nudes possess a sensuality unusual in Redon's work. The head growing on a stem is a late reminiscence of the sad flower-heads of his more sombre earlier years.

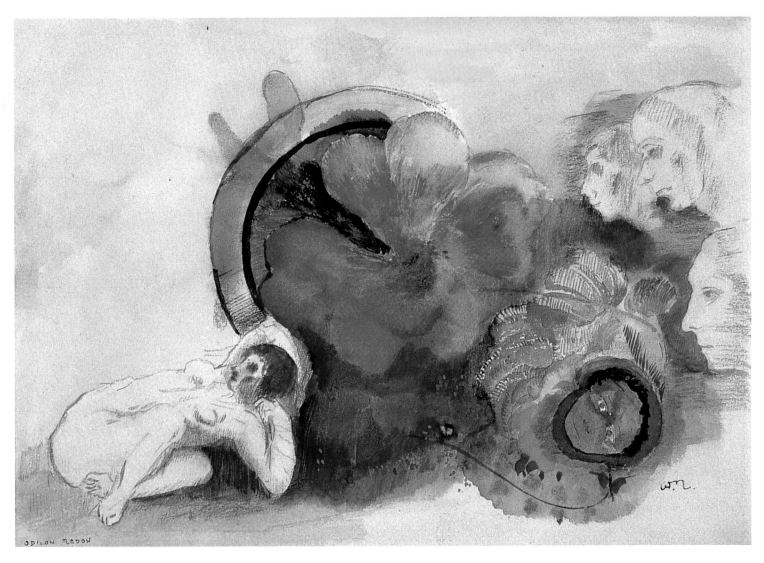

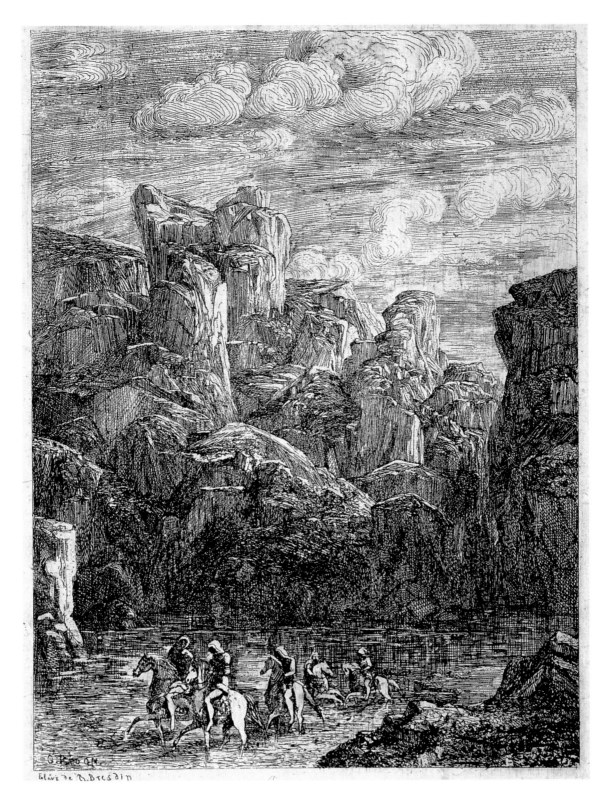

Other large-scale works may be taken as confessions or experiments not directly related to broader social drives. Much so-called 'post-modern' art seems to belong to this category. Certain contemporary artists seem to express a more or less conscious irony about the ideological implications of large-scale works. Some produce huge canvases in which the great collective issues are treated with derision, while others, who appear to assume that even their most intimate experiences are of vital concern to the world at large (or who merely fail to grasp the significance which inevitably attaches to large canvases), paint on the scale of the *Raft of the Medusa* subjects which could more appropriately be dealt with on a modest scale, befitting the artist's confiding manner.

The Ford, 1865
Le Gué
Etching
Signed "O. Redon, student of Bresdin"

PAGE 36:
Two Figures Fleeing or *Adam and Eve*
Deux personnages fuyant, dit aussi
Adam et Eve
Charcoal, 60 x 45 cm
Private collection

For scale is commanded not merely by formal but by pyschological considerations. What someone tells us in private at the end of a meal would have a quite different meaning if it were communicated to a large audience through a public address system. Redon's work speaks in an intimate tone, even when he paints large surfaces, as he did in Domecy, in Gustave Fayet's (1855–1899) Fontfroide Abbey or in the home of the composer Ernest Chausson in Paris; such works were intended to be seen only by the families that commissioned them and by their guests.

The work of an artist like Redon thus helps one to establish a distinction between the social and private domains (the latter broadened to include the family and its circle of friends). This distinction has practically disappeared in the arts today. Yet when artistic influence flows outwards, however imperceptibly, from the privacy of the individual or family towards society, we can expect authentic works to result. When, on the other hand, it flows the other way, in dogmatic and authoritarian fashion, inward, from the social to the private realm, we can expect a greater number of conventional and academic works.

Redon knew and loved many painters, writers and poets. Older painters, like Corot, offered advice: "Place a certainty next to each uncertainty..." he told Redon. The writers – pre-eminent among them Stéphane Mallarmé

Ophelia, c. 1900–1905
Ophélie
Pastel on board-backed paper, 49.5 x 66.5 cm
New York, The Ian Woodner Family
Collection

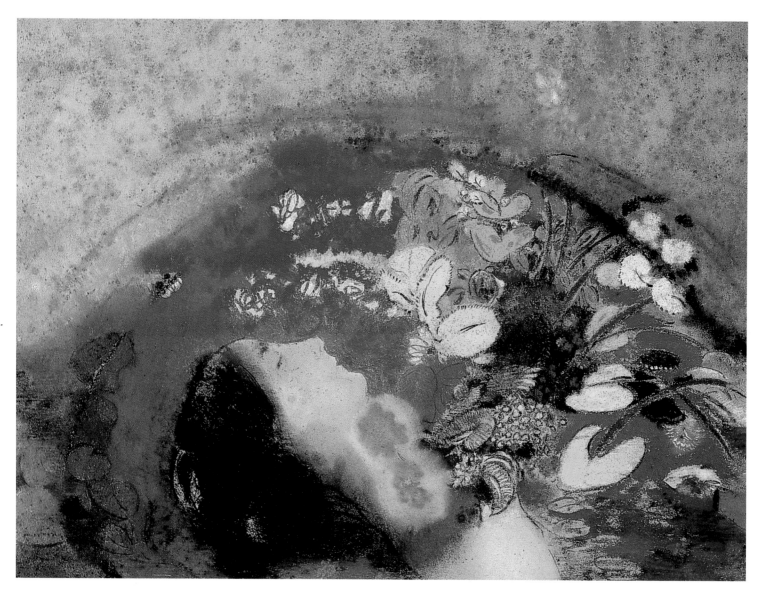

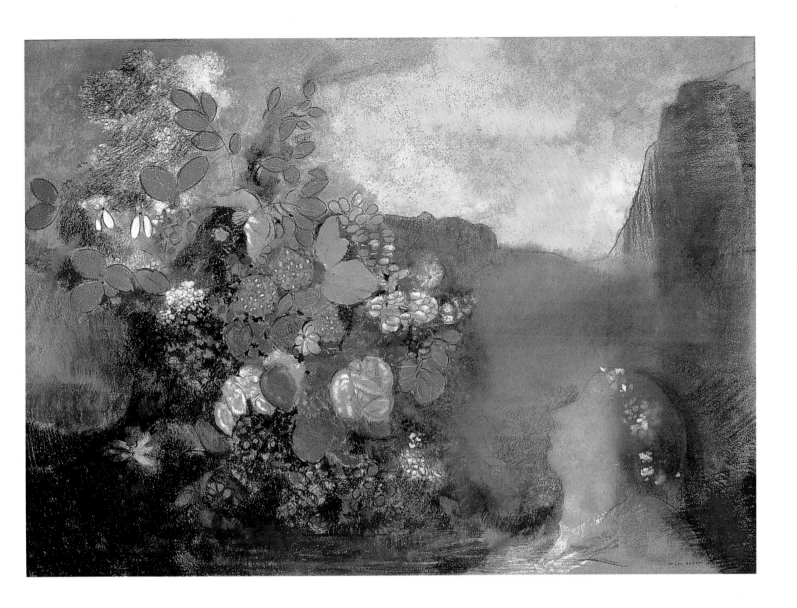

and Joris-Karl Huysmans – gave him their enthusiastic support. Redon was a passionate music lover. His friend Armand Clavaud taught him not only about botany and microscopic forms such as cells and infusoria, but also about evolution, Indian philosophy and Buddhism. Culture was Redon's world.

Redon lived at a time of great social and political agitation – but it seems that he did not feel it his business to express such things. In the passage quoted earlier, in which the artist admits to having spent days on end lying on the ground and watching the clouds go by, he adds that this continued "a long time after [childhood]", and he adds: "I dare not say till what age, for you would call me an incomplete man." And he was no doubt "incomplete" to the extent that the circumstances of his childhood had deprived him of many things, including the crucial phase of socialization which begins around the age of six or seven. But this very lack made him an exceptional being, opening up for him the realms of imagination and representation that underpin active life. He found equilibrium only in the acceptance of his singularity.

Consider nonetheless the events that marked his 1840–1916 lifespan. At the time of the 1848 revolution, the artist was only eight years old and still in exile among the pines and shepherds of Peyrelebade. He reached Bordeaux at about the time Louis Bonaparte was proclaimed Emperor of the French under the name Napoleon III. During the decades that followed, the

Ophelia among the Flowers
Ophélie dans les fleurs
Pastel, 64 x 91 cm
London, National Gallery
The mad Ophelia is carried off by the current, surrounded by the "fantastic garlands" that she had gathered, "as one incapable of her own distress,/ Or like a creature native and indued/ Unto that element", till her garments pull her "to muddy death." (Hamlet, Act IV, Scene 7)

French industrial revolution transformed the country – a development punctuated, in 1870, by a disastrous war in which Redon briefly took part. He was then thirty years old.

The tremendous social upheavals of the age, the development of militant unionism, the confrontation between the Catholic Church and the secular French state, the Dreyfus Affair and the outbreak of the First World War passed him by, leaving no trace in his *œuvre*. And that is as it should be: "I belong to no party", he wrote to André Bonger, the collector who had promoted his work in Holland. "I have always felt that an artist is alone and can only be alone. Though I don't know how to classify myself today, I do know where I am not. And nothing else." (Bacou, 1956, I. p. 30, quoted in the *Catalogue de la Donation Arï et Suzanne Redon*, p. 58). And finally, in 1913, he jotted down the following observation: "I see in a window a book entitled *Social Art*. It is repugnant. I open it nonetheless, and see 'Socialization of Beauty', and I close it."

TOP:
Profile
Profil
Oil on board, 24.5 x 28.5 cm
Private collection

RIGHT:
Vase of Flowers and Profile
Vase de fleurs et profil
Oil on canvas, 65 x 81 cm
Private collection
These two works, like those on the preceding pages, mainly serve as pretexts for Redon to depict flowers and butterflies in all their brilliant colours.

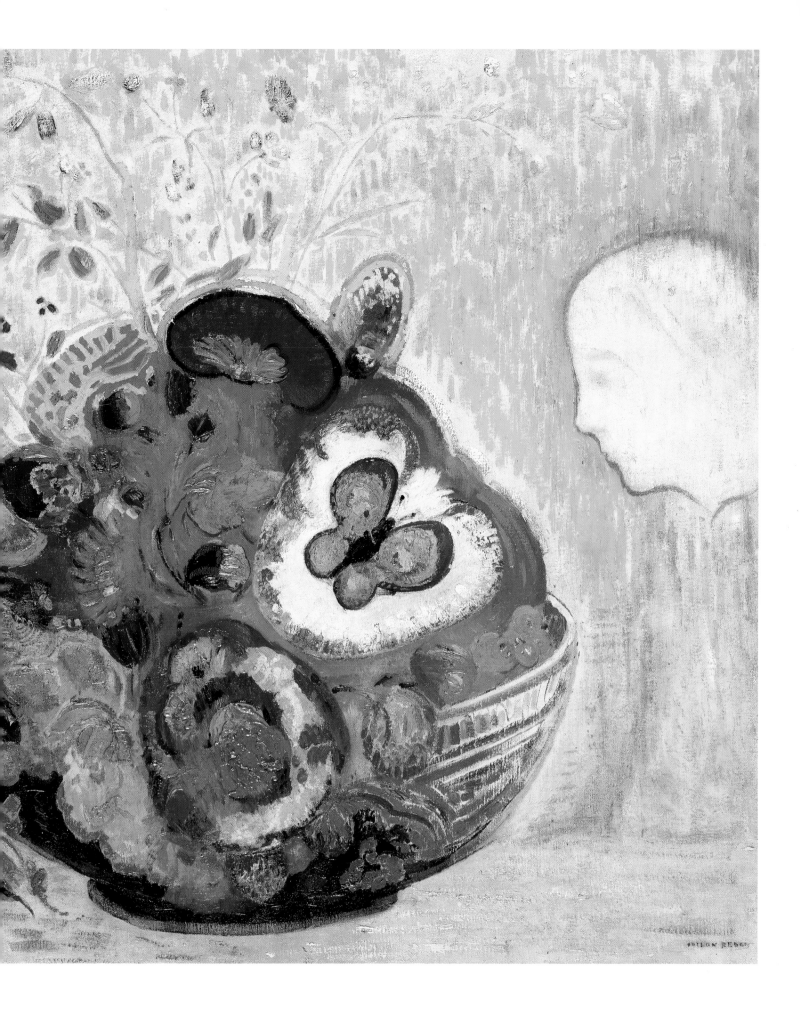

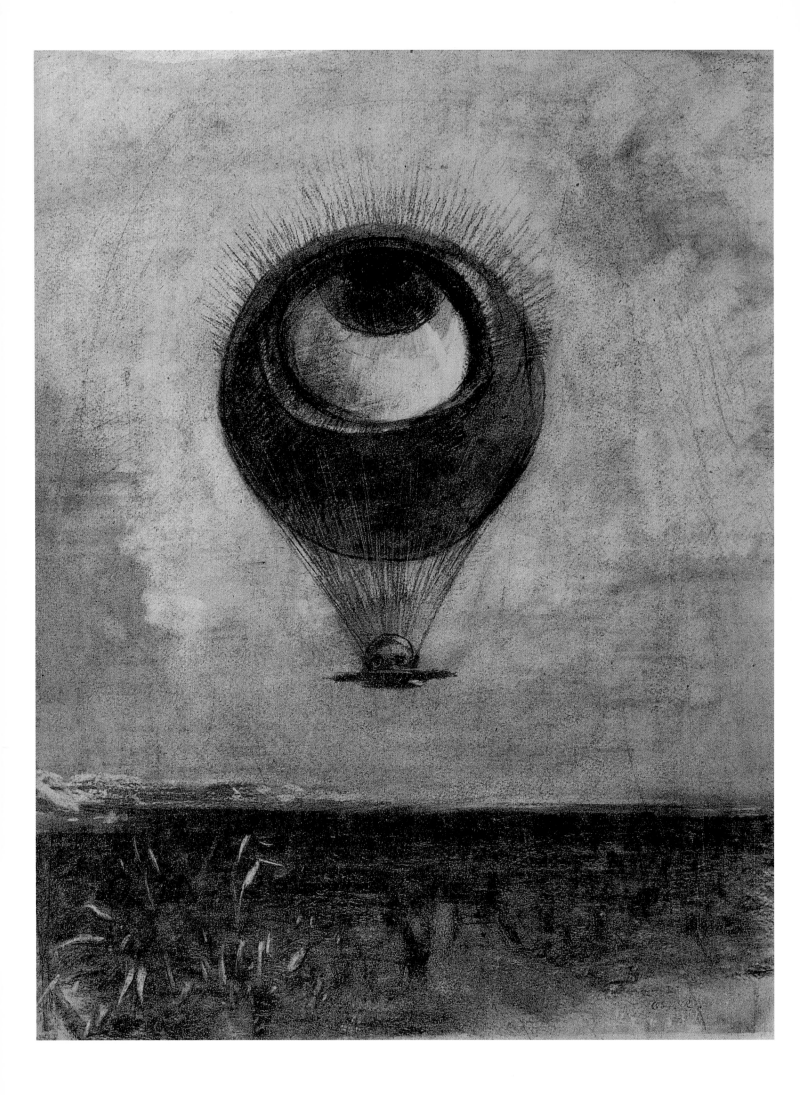

Black

Everything begins with black. Redon wrote the word with a capital – *Le Noir*, *les Noirs* (he also spoke of *mes ombres*, 'my shadows') – to refer to his nocturnal visions bathed in the half-light he so admired in Rembrandt, and which he created through charcoal or lithographer's ink. "In the last analysis," he said, in a letter to the painter Emile Bernard (1868–1941), "black is the most essential colour, is it not?" True, at the same time Redon was executing occasional works in oil and pastel, landscapes (already discussed), self-portraits, some portraits of his wife and a number of copies of masterworks in museums. He executed eleven etchings in 1865 and 1866, while working with Rodolphe Bresdin. The Louvre owns over five hundred Redon drawings. They include studies of trees, plants, mountains, nudes and imaginary subjects. But the major part of Redon's production between 1865 and 1890 was devoted to charcoal drawings and lithography.

Close to forty and in full possession of his artistic means, Redon made his name with the publication of several collections of lithographs. "About 1875," he declared, "everything came to me in the form of pencil or charcoal. This rather ordinary medium, which has no inherent beauty, facilitated my attempts to render both chiaroscuro and the invisible. Charcoal allows no light-heartedness; it has a certain gravity. Only emotion allows anything to be made of it" (quoted by Claude Roger-Marx: *Redon. Fusains*, 1950, p. 8).

He had first considered a series of drawings based on the *Pensées* of Pascal. But this produced only two pencil drawings, one of them bearing the inscription "Le silence éternel de ces espaces infinis m'effraie" (The eternal silence of those infinite spaces frightens me). Redon gave up the idea, concluding that the subject was "too abstract, even for me".

His first sequence of lithographs was the ten plates assembled under the title *In Dream* (1879). Today, Redon's approach may seem familiar – Surrealism and other trends devoted to the imagination, from Alfred Kubin to Roland Topor, have accustomed us to it – yet the mood of Redon's work remains completely original. The series includes one of the artist's finest and most enigmatic plates: *Vision*. Two minute human figures, a man and a woman, are seen walking diagonally past the viewer in an attitude which suggests Orpheus leading Eurydice out of Hades. The man's right hand grasps what appears to be a crown of laurels and he carries, slung over his shoulder, an object which might be his lyre. They flee across a pavement resembling an enormous chessboard. Behind them stand two tremendous pillars. The darkness behind the pillars is impenetrable, and between them, surrounded by a halo resembling an *aurora borealis*, a colossal eyeball floats weightless, its pupil turned upwards.

The work is typical of Redon in that no single interpretation is decisive,

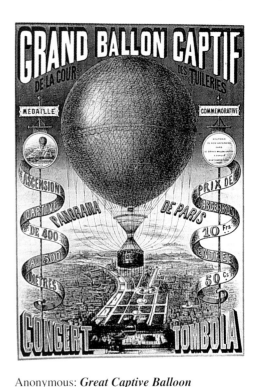

Anonymous: *Great Captive Balloon*
Anonyme: Grand Ballon Captif
Lithograph poster
Paris, Bibliothèque de France
"The eye, like a strange balloon, turns towards the infinite." The themes of the eye and the decapitated head are very common in Redon's work, and no doubt relate to the artist's childhood when, as a very young baby he was stranded far from his family. The eye turned upwards toward sky and ideal would thus be a sublimation of his predicament through art. Hot-air balloons played an important role during the Prussian War of 1870; the besieged Parisians regularly used them to communicate with the rest of France.

PAGE 42:
Eye-Balloon, 1878
Œil-Ballon
Charcoal, 42.5 x 33.5 cm
New York, The Museum of Modern Art

LEFT:
Cyclops
Cyclope
Black crayon, 11.5 x 15.9 cm
New York, John Rewald Collection

MIDDLE AND BOTTOM:
Grandville: Engravings for *A Different World*,
1844, and for *Le Magasin Pittoresque*, 1847

though many are possible. Some authors have compared it to Gustave Moreau's *Apparition*, but the narrative content of Moreau's work is clear; at that time, everyone was expected to know the story of Salome. Looking at Redon's work, on the other hand, the spectator is like a child who cannot quite understand what is going on – or even like the dreamer himself. The upward-swivelling eye could be that of a disembodied Cerberus, the watchdog of hell, or even – when we remember that Redon was aware of the unconscious – the vigilant eye of the superego, momentarily averted and thus allowing repressed material to escape. ("Everything", Redon declared, "arises out of a docile submission to the advent of the unconscious"). How

PAGE 45:
The Cyclops, c. 1898–1900
Le Cyclope
Oil on wood, 64 x 51 cm
Otterlo, Rijksmuseum Kröller-Müller
The sometimes naive, sometimes amorous Cyclops, like the "eye" in its various forms, represents Redon himself, that perpetual observer. His contemporary, Grandville, also liberated the eye from the body, but in his visions it assumes a more aggressive and manic aspect.

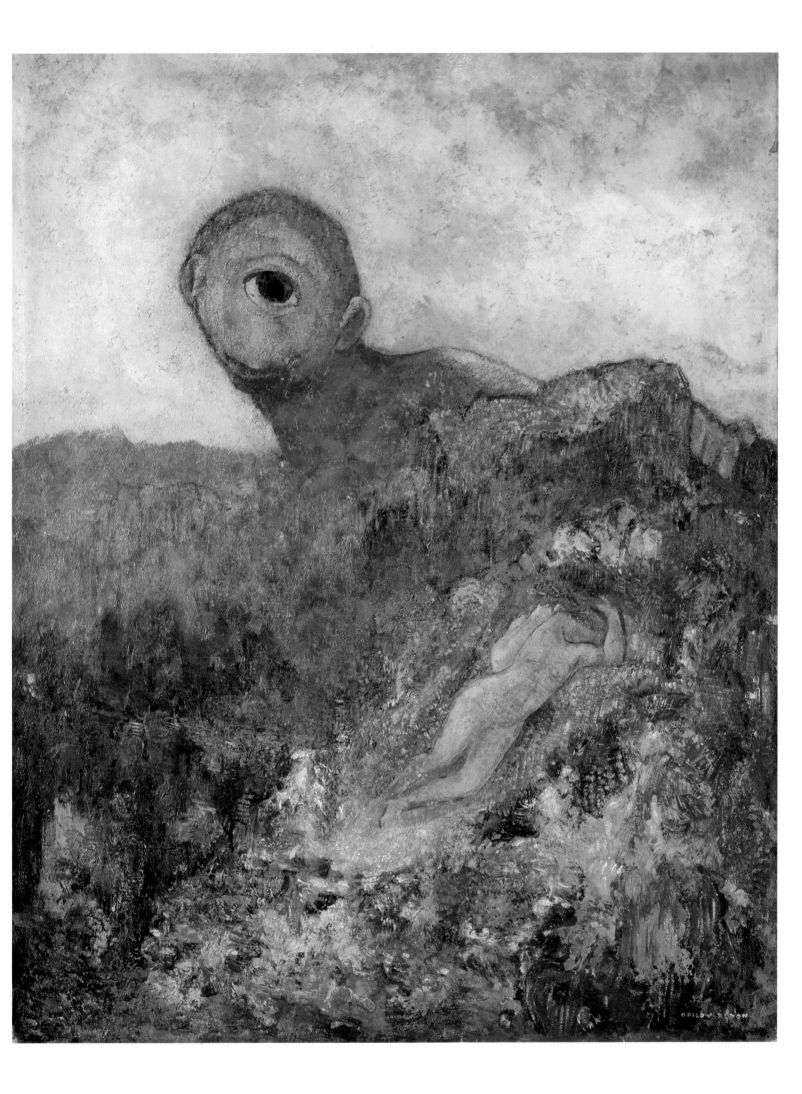

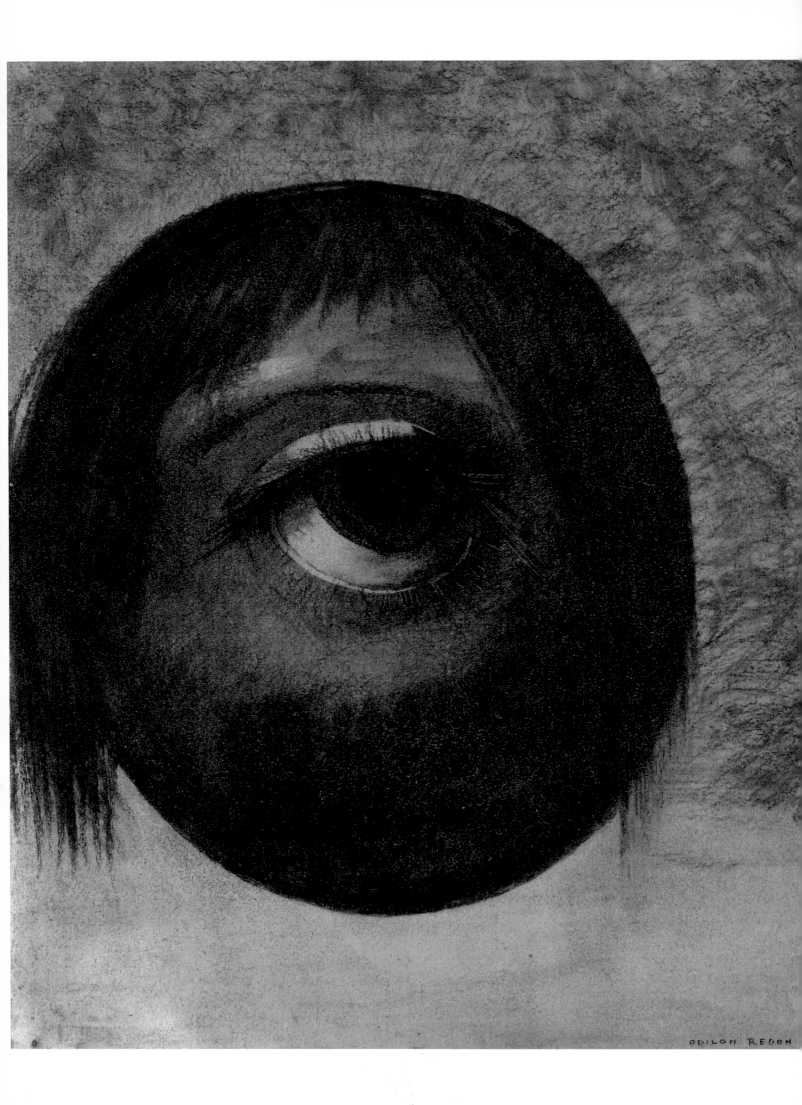

remote this is from Moreau's Salome, amazed at the apparition of a blood-stained head!

Redon was at pains to specify why he admired Moreau. He stressed the differences between Moreau and himself, noting that the figures painted by the older artist "are frozen in a sort of optical rhetoric" and concluded that Moreau is "a great water-colourist, without any doubt. A paint-worker who knew painting well, one of the few who did in his day". But, with perception laced with humour, he added: "In the accessories, what admirable virtuosity! what marvellous embroideries, with their old and faded silks, for the cushions of some old lady, a dreamer of luxury, whose life has been impeccable, but who closed her eyes to poverty... A bachelor in life, in art too he was a refined bachelor, hermetically excluding the conflicts of his life. His work is the fruit of this; it is art – nothing but art – and that is no small thing" (*Lettres*, p. 39). The comparison with Moreau clearly brings out how important formal invention is in determining our perception of the subject.

Three years later, in 1882, Redon again depicted an airborne eye. This time it was in the series *To Edgar Poe*, and it assumed the shape of a balloon (cf. ill. p. 42): "L'œil comme un ballon bizarre se dirige vers l'infini" (The eye, like a bizarre balloon, moves towards the infinite). In this print, the eye faces the viewer, but is, here again, turned ecstatically to the sky. Suspended beneath this peculiar ballon one can just make out a severed head resting on a dish.

A similar eye is the most striking feature of a series entitled *Les Origines* (1883). It is again turned upward, but this time set in the forehead of a

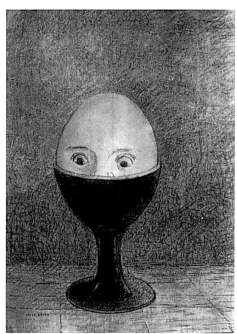

The Egg, c. 1885
L'Œuf
Charcoal, 45 x 34 cm
Belgrade, Narodni muzej
The expression of this egg rammed into its cup evokes the terrifying enforced immobility of nightmares.

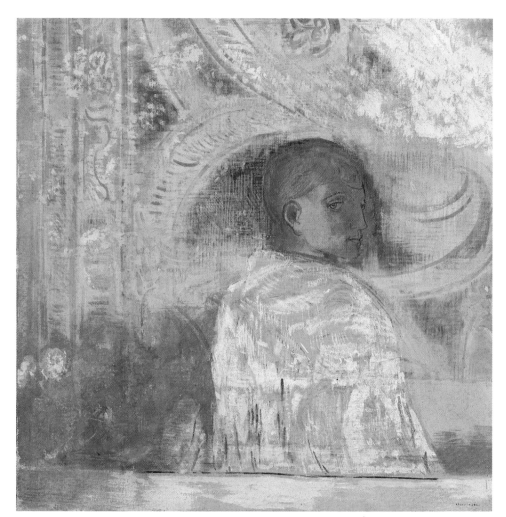

LEFT:
The Glance
Le Regard
Oil on canvas, 73 x 73 cm
Private collection
Redon mostly portrays faces in profile. When they are turned towards the spectator, they generally reveal a morose or hallucinatory expression – unless the eyes are simply closed. This inquiring glance directed at the spectator is therefore quite unusual.

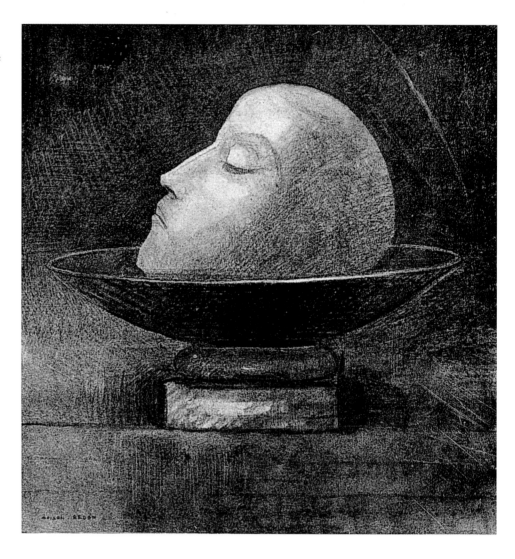

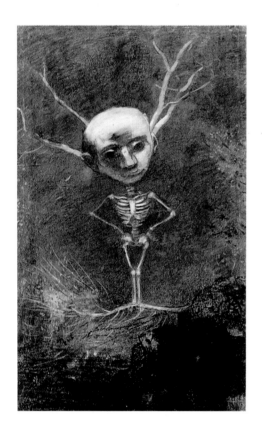

cyclops who greets the world with a cretinous smile. In the title, the latter is rather oddly designated by the term 'polyp' – perhaps by analogy with the name of Polyphemus, the cyclops who sought to devour Ulysses. Other works present the same subject: the charcoal *Vision* in the Baltimore Museum (ill. p. 46), the lithograph *A first vision was perhaps attempted in the flower* (1883), and later, *Everywhere pupils blazed*, a print in the first series devoted to Flaubert's *Temptation of Saint Anthony*. In all these plates, the eyeball is perfectly spherical, a form anticipated in a superb charcoal drawing entitled *The Cannonball*. Huysmans was particularly taken with it and described it in his novel *A Rebours* as hanging in the living room of the fictitious Des Esseintes. The Louvre also owns a black pencil and stump drawing bearing the same title, in which the cannonball stands alone with its shadow.

One might easily imagine a progression between the blind sphere touched by "a sort of Buddhist monk", which might represent a first and hermetic form of the riddle of existence, and the levitating eye, turned heavenward in the dark and lit by its own strange halo. Flying figures were a commonplace of 19th century art. Puvis de Chavannes (1824–1898) painted various flying women (he provided some of them with harps), and Symbolist art as a whole delighted in such imagery. But in Redon's case, the subject is never conventional. Severed heads frequently appear in the Black works. They are to be seen floating inside a bubble, drifting like particles suspended in a liquid, or simply resting, with a melancholy but an-

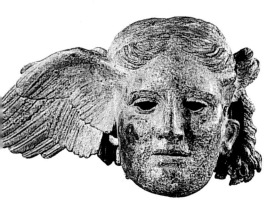

imated and attentive expression, on a dish or a pedestal, as does the lifeless and expressionless head of John the Baptist in religious iconography (*Head of a Martyr*, ill. p. 48).

Others appear in unusual attitudes: *The Cactus Man* (ill. p. 55), for instance, is a prickly head with negroid features that sprouts from a pot-holder; *Marsh Flower*, in the series *Homage to Goya* is a luminous head, suspended from a stalk like the bell of a lily-of-the-valley, and the famous *Smiling Spider* (ill. p. 50), whose charcoal version was executed in 1881, can

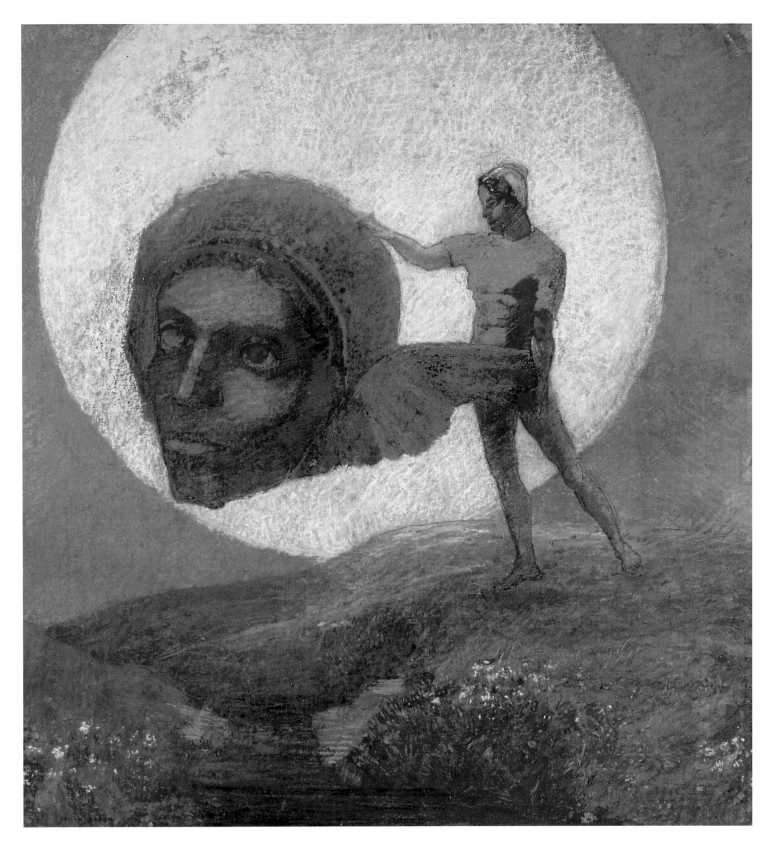

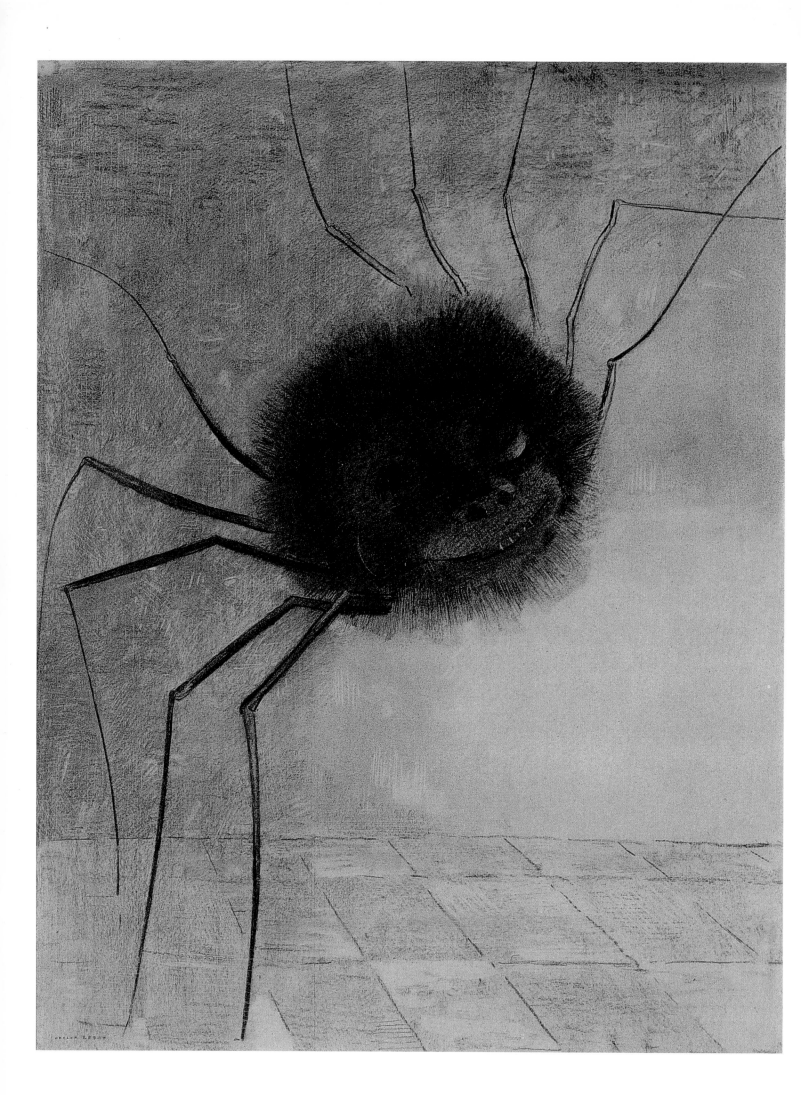

be seen as a bodiless head smiling sardonically as it scampers about on ten slender articulated legs. One might also mention *Guardian Spirit of the Waters*, a charcoal drawing of 1878 (detail, ill. p.96), which represents a tremendous bodiless head hovering over the ocean above a tiny sailing vessel, the *Winged Head* whose ears extend into feathers, *The Egg*, a lithograph of 1885 (ill. p.47), rammed into an eggcup with its eyes emerging,

RIGHT:
The Raven, 1882
Le Corbeau
Charcoal, 40 x 27.9 cm
Ottawa, National Gallery of Canada
Illustration for the cover of Poe's *Tales of the Grotesque and Arabesque*. "It is the wind and nothing more! / Open here I flung the shutter, when, with many a flirt and flutter / In there stepped a stately Raven of the saintly days of yore" (Edgar Allan Poe: *The Raven*, stanzas 6–7).

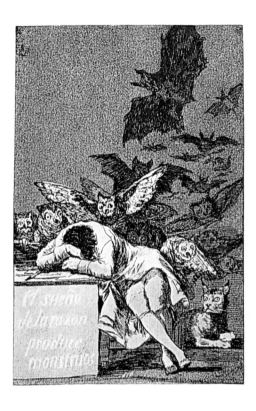

TOP:

Francisco José de Goya: *The sleep of reason engenders monsters*, 1797–1798
Plate 43 of *Los Caprichos – El sueño de la razón produce monstruos*
Redon, a native of Bordeaux, could hardly fail to be aware of the astounding *œuvre* of Goya, who had also been a resident of that town. Though Redon honoured the Spanish artist with his *Homage to Goya*, his gentle temperament was quite at odds with Goya's ferocious genius; the two artists have points of contact but cannot justly be compared.

PAGE 50:

The Smiling Spider, c. 1881
L'Araignée qui sourit
Charcoal, 49.5 x 39 cm
Paris, Musée du Louvre
This "terrifying spider, its human face lodged in the middle of its body" decorated the bedroom of Des Esseintes in Joris-Karl Huysmans' novel *A Rebours*.

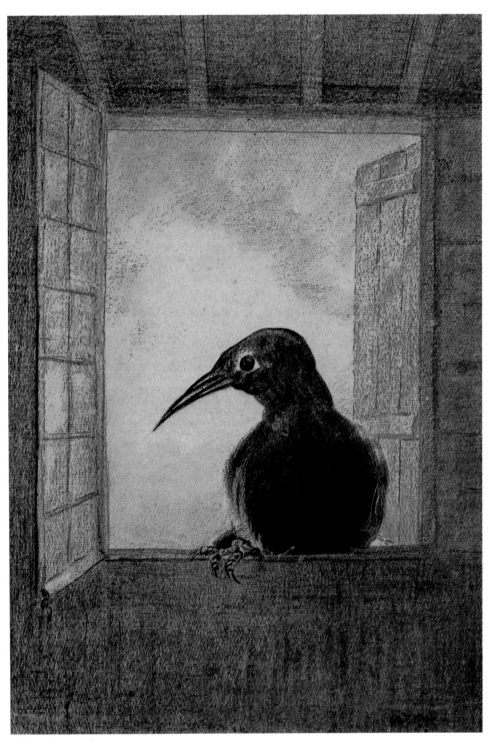

and *The Balloon*, a charcoal drawing of 1885, in which a head appears in profile inside a balloon, rather like the filament inside a light bulb. Finally, there is the image dear to the Symbolists (and frequently used by Redon) of Orpheus' severed head, which continues to sing as it is carried off by the current on the raft of the lyre. This is a substantial collection of severed heads; what are we to make of them?

PAGE 50:
Head on a Stalk or **Strange Flower** or **Little Sister of the Poor**
Tête sur une tige, dit aussi La Fleur étrange, dit aussi La Petite sœur des pauvres
Charcoal, 40.2 x 33 cm
Chicago, The Art Institute of Chicago
"There again a desert, desolate, arid site like the landscapes of moonmaps, in the midst of which arises a stalk from which there hangs like a host, like a round flower, a bloodless face of meditative cast", Huysmans wrote in 1881, no doubt thinking of this charcoal drawing.

RIGHT:
Mysterious Head
Tête mystérieuse
Watercolour, 18.4 x 16.7 cm
New York, The Ian Woodner Family Collection

Madness or **Mephisto**, 1883
La Folie, dit aussi Méphisto
Charcoal, 36.2 x 31.4 cm
Paris, Musée du Louvre

There can be no definitive answer. The contemplative immobility of many of these heads might evoke the enforced immobility of the very young child. One might be tempted to establish a connection with the infant Odilon, far from his family and seeking solace in his dreams. The melancholy expressions of some of these heads give weight to this interpretation. Others however, (*Germination* in the series *In Dream* or "Embryonic Beings" in the *Homage to Goya* collection), have the smug expression of simpletons. Some of these figures – the spider, Cactus-man and *Armour* (a head shown in profile and covered in spines, ill. p. 21) – seem potentially aggressive. The last-named of these is still attached to a body.

Attempting to establish connections between these works and Redon's experience does not exhaust the possibilities of interpretation, but it does suggest why the spectator may sense an inexplicable affinity between them. They perhaps express the pitiful impotence of the individual confronted with the great forces and events which command his life and determine his fate. This applies equally to the winged horse, a constant feature of Redon's work. *His impotent wing could not lift the beast into those dark spaces*, the seventh plate of the series *Les Origines*, shows a winged white horse rearing up and falling back heavily on its hindquarters. An 1889 lithograph, *Captive Pegasus*, represents the winged steed of the poet restrained and prevented from taking flight. In several other works, such as *Demons* or *Fallen Angel*

(ill. p.58) beings possessed of wings move earthbound, their faces haggard and backs bent, through a sterile land.

In 1888 Redon published a first series of plates devoted to Gustave Flaubert's (1821–1880) *The Temptation of Saint Anthony*. Flaubert's strange, grandiloquent work has elements in common with Goethe's *Second Part of Faust*: both works are unusually dense and were not really intended for the stage, despite their dialogue form. Redon devoted three entire albums, a total of 42 plates, to *The Temptation*, in which Flaubert offers an encyclopaedic and carefully documented overview of the state of religious speculation during the first centuries of the Christian era.

TOP:
Marsh Flower, 1882
Fleur de marécage
Charcoal, 49 x 33 cm
Otterlo, Rijksmuseum Kröller-Müller
Huysmans: "In his features there was something of the sorrow of the worn-out pierrot, of an old clown who weeps over his sagging features and the distress of an ancient lord eaten up by spleen."

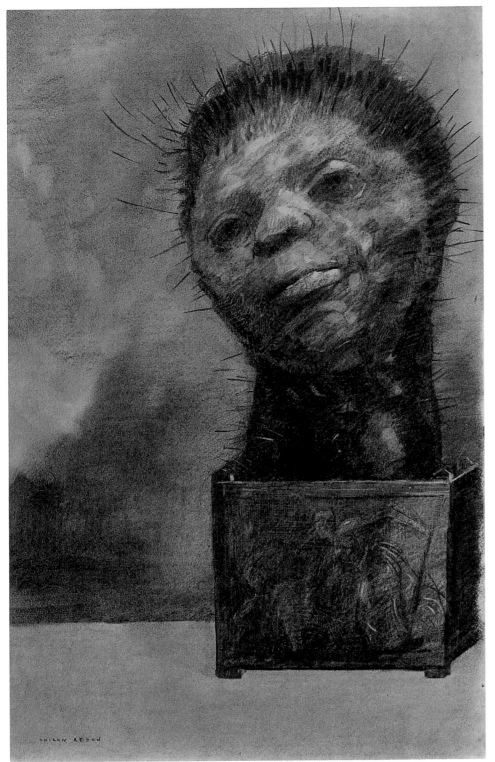

LEFT:
The Cactus Man, 1882
L'Homme Cactus
Charcoal, 46.5 x 31.5 cm
New York, The Ian Woodner Family Collection

PAGE 54:
The Masked Anemone
L'Anémone masquée
Watercolour, 24.5 x 17.5 cm
Private collection

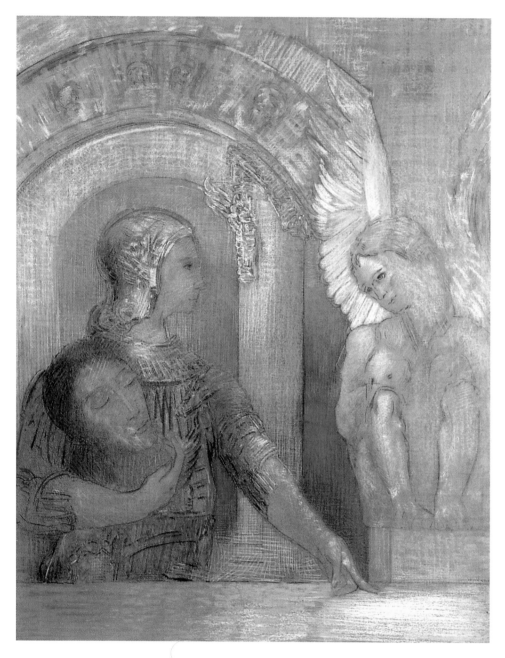

LEFT:
Mystical Knight or ***Œdipus and the Sphinx,***
c. 1894
Le Chevalier mystique, dit aussi Œdipe et le
Sphinx
Charcoal of 1869, embellished with pastel,
100 x 80 cm
Bordeaux, Musée des Beaux-Arts

BOTTOM:
Gustave Moreau: ***Œdipus and the Sphinx***,
c. 1864
Œdipe et le Sphinx
Oil on canvas, 206.4 x 104.7 cm
New York, The Metropolitan Museum of Art
Redon felt deep admiration for this painting:
"I saw *Œdipus and the Sphinx* for the first
time when I was young; naturalism was at its
height then, and how consoling I found the
work! I have long kept the memory of that
first impression…"

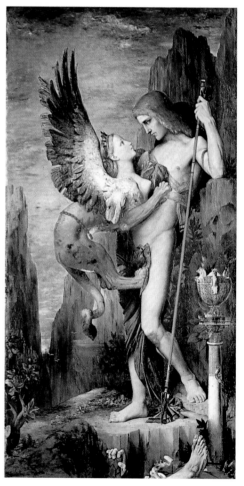

Redon obviously felt drawn to the visionary character of the book; its composition had been suggested to Flaubert by a painting (then attributed to Pieter Bruegel the Elder (c. 1525–1569) which he had seen in the Palazzo Balbi in Genoa in 1845. Flaubert's presentation of fantastical and bewildering conceptions might have been designed to attract Redon, who loved mythical and mystical figures precisely to the extent that they allowed him to express things which would otherwise have remained unutterable – particularly matters relating to 'the origins'.

Oannes, one of the protagonists of *The Temptation of Saint Anthony*, appears not only in lithographs, but in several late paintings (cf. ill. p. 70). Flaubert, apparently prompted by the hybrid imagery of the painting he had seen (either a copy of Hieronymus Bosch or the work of one of his followers; it was certainly not a Bruegel), presents him as "a singular being, with the head of a man on the body of a fish. He advances standing upright, beating the sand with his tail." The derision this apparition prompts in Saint Anthony elicits the plaintive request: "Respect me! I am coeval with the origins…".

"The origins". This, it seems, was the main subject of Redon's now pain-

PAGE 57:
Winged Old Man with Long White Beard
Vieillard ailé, à longue barbe blanche
Pastel, 56.9 x 39.7 cm
Paris, Musée d'Orsay
The winged old man is often an allegorical
representation of Time, but, with Redon, it is
best to avoid too precise an interpretation,
given the artist's desire to create the kind of in-
definite outlines that could favour dreams.

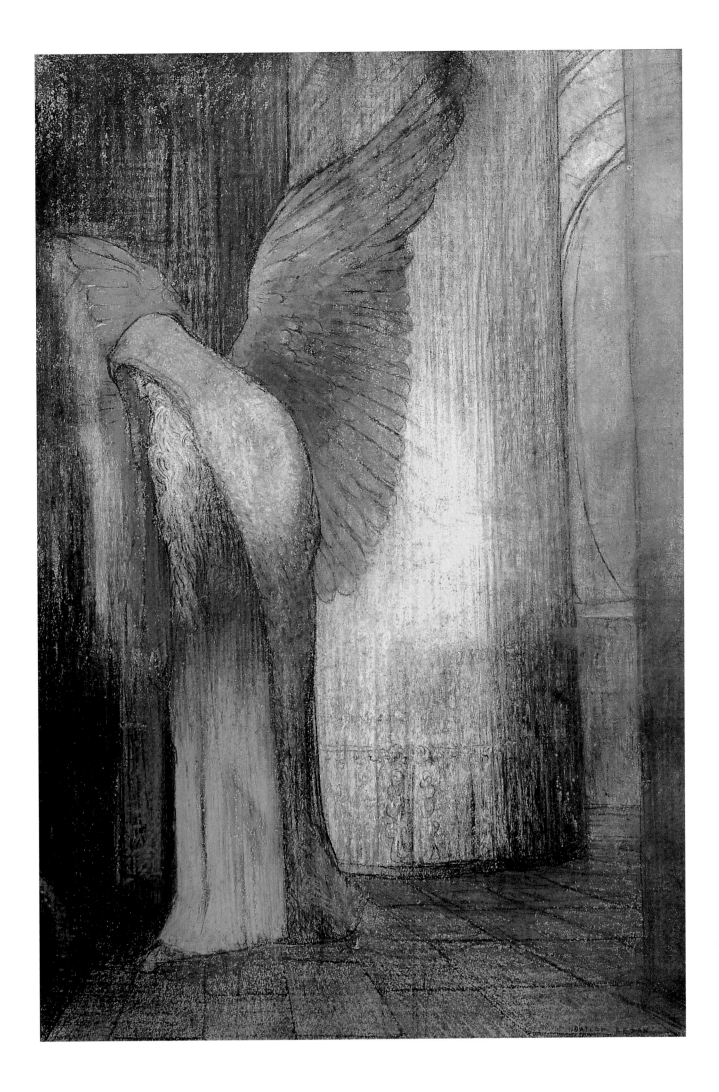

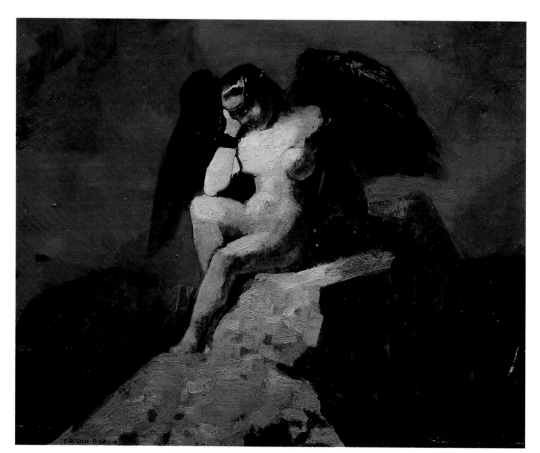

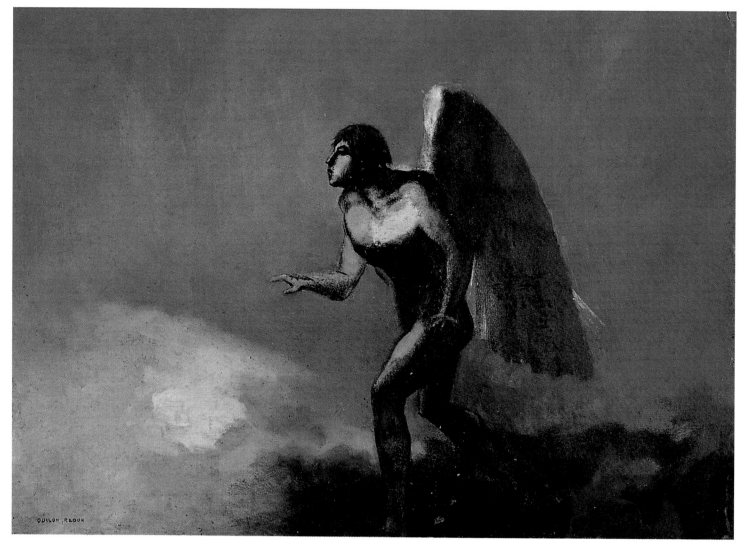

PAGE 58, TOP LEFT:
Preparatory drawing for "Thought" (detail),
before 1880
Dessin pour la Pensée (détail)
Graphite on paper, 27 x 37.5 cm
New York, The Ian Woodner Family
Collection

PAGE 58, TOP RIGHT:
Thought, before 1880
La Pensée
Oil on wood, 22 x 26 cm
New York, The Ian Woodner Family
Collection

PAGE 58, BOTTOM:
Winged Man or ***Fallen Angel***, before 1880
L'Homme ailé, dit aussi L'Ange déchu
Oil on board, 24 x 33.5 cm
Bordeaux, Musée des Beaux-Arts
"The eternal silence of these infinite spaces
frightens me…" (Pascal: *Pensées*).

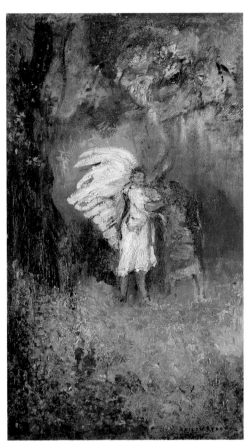

TOP:
Jacob and the Angel
La lutte de Jacob et de l'Ange
Oil on wood, 29 x 17 cm
Private collection

BOTTOM RIGHT:
Angel of Shadows or ***The Angel of the Book***
L'Ange des Ténèbres, dit aussi L'Ange du
Livre
Lead pencil embellished with gouache,
17 x 13.5 cm
Private collection
The figure of the winged man has various
meanings in Redon's work. The most original
in its symbolic overtones is the winged man
groping his way forward instead of flying, a
further evocation of the profound sense of im-
potence that Redon himself had to overcome.
In this work we see an allegorical figure; the
book that he is leafing through is Dante's
Inferno.

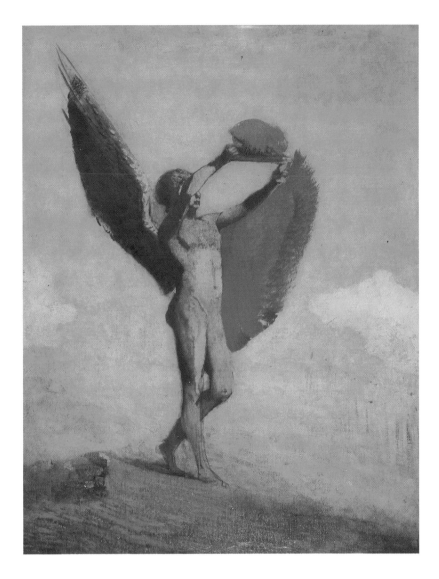

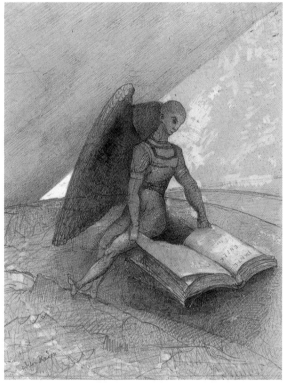

BOTTOM LEFT:
Icarus or ***The Offering***
Icare, dit aussi L'Offrande
Oil on board, 52 x 38 cm
Japan, Private collection

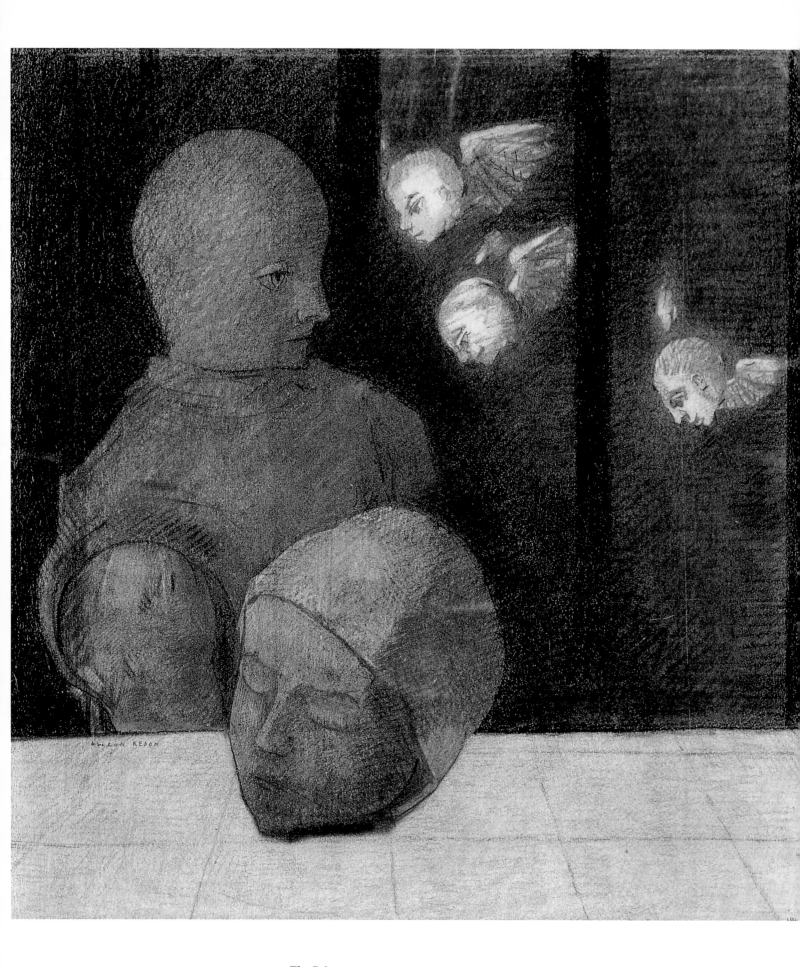

The Prisoner
Le Prisonnier
Charcoal, 38.8 x 36 cm
Paris, Musée du Louvre
(Musée d'Orsay Collection)

"A decapitated head", in Redon's description, "placed on a chequered table behind which there is a young, bareheaded monk and three little winged spirits, smiling mischievously at him."

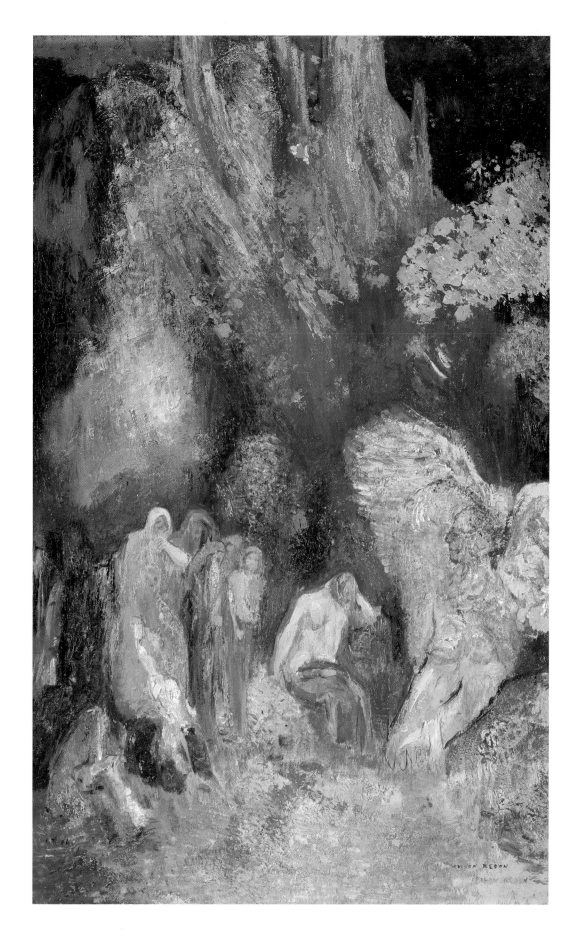

Enchanted Cave or **Cave of Shadows** or
Cave of Pythia
La Grotte enchantée, dit aussi La Grotte des
Ténèbres, dit aussi La Grotte de la Pythie
Oil on wood, 46 x 29 cm
Japan, Private collection

"The theme of the winged man is often over-
cast with doubt; mythical or religious in inspi-
ration, this last example, the merest pretext for
a harmonious play of colour, is a fable, enig-
matic yet luminous and almost serene."
(A. Lacau St Guily – Wildenstein Institute)

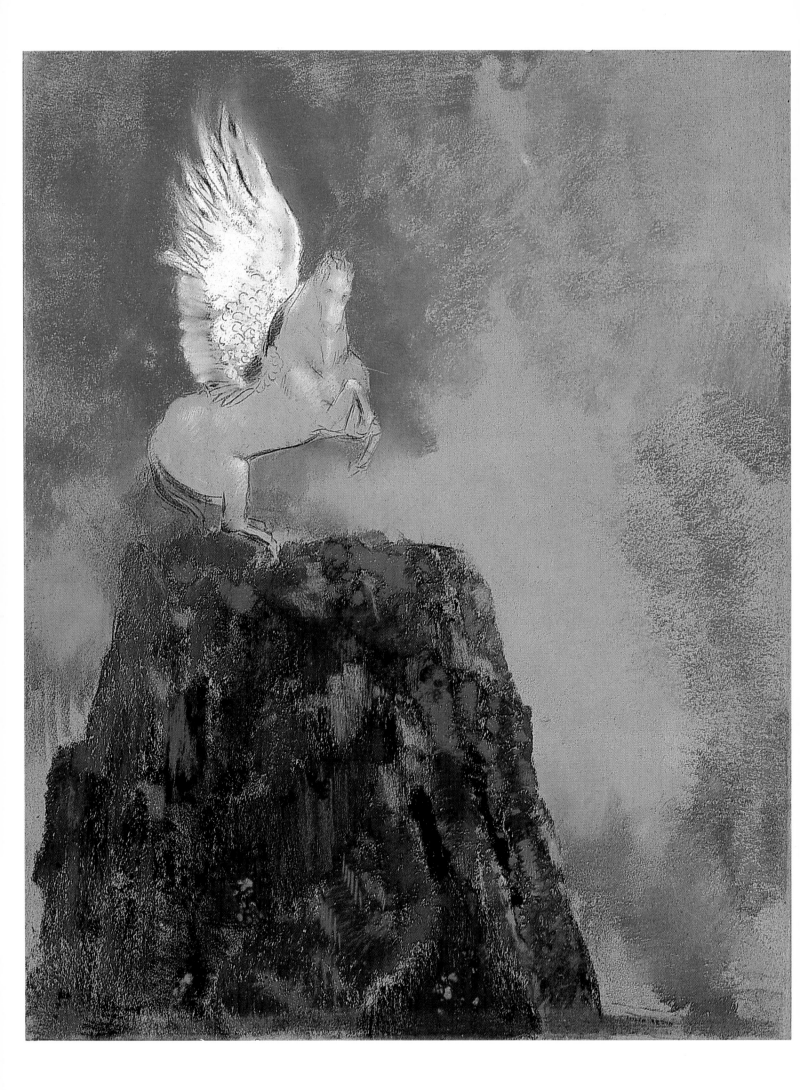

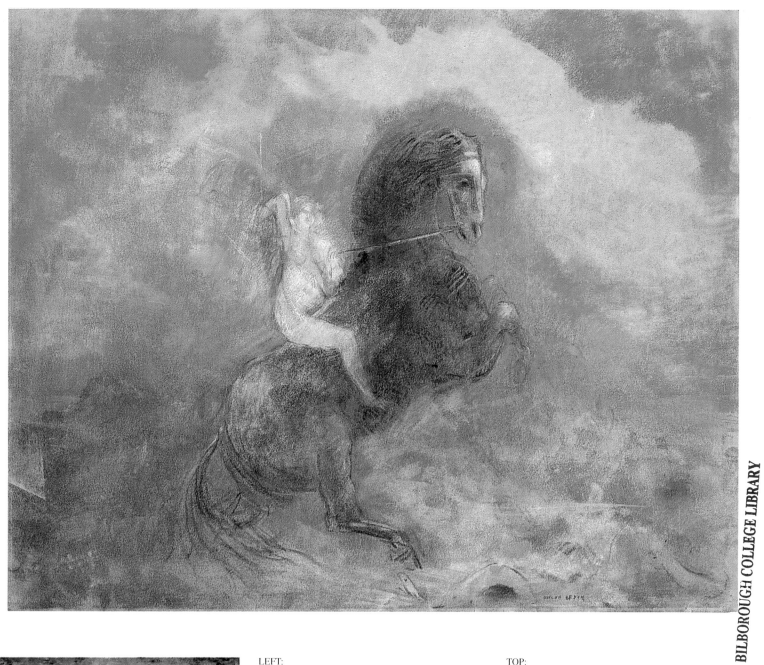

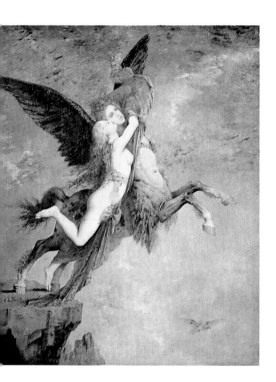

LEFT:
Gustave Moreau: *The Chimaera*, 1862
La Chimère
Oil on parquet panel, 33 x 27.3 cm
Cambridge (MA), Fogg Art Museum,
Harvard University
Redon may well have known Moreau's
painting of this mythical figure.

PAGE 62:
Pegasus, c. 1900
Pégase
Pastel, 80.7 x 65 cm
Hiroshima, Hiroshima Museum of Art

TOP:
Brunhild* or *The Valkyrie
Brunehilde, dit aussi La Walkyrie
Pastel, 54.4 x 67.5 cm
New York, The Ian Woodner Family
Collection
Brunhild, the heroine of *The Valkyrie* and *The
Twilight of the Gods*, is shown here in the last
opera of Wagner's *Ring Cycle*. Siegfried has
been treacherously stabbed by Hagen, and
Brunhild spurs her steed Grane to leap onto
the pyre where Siegfried's body lies.

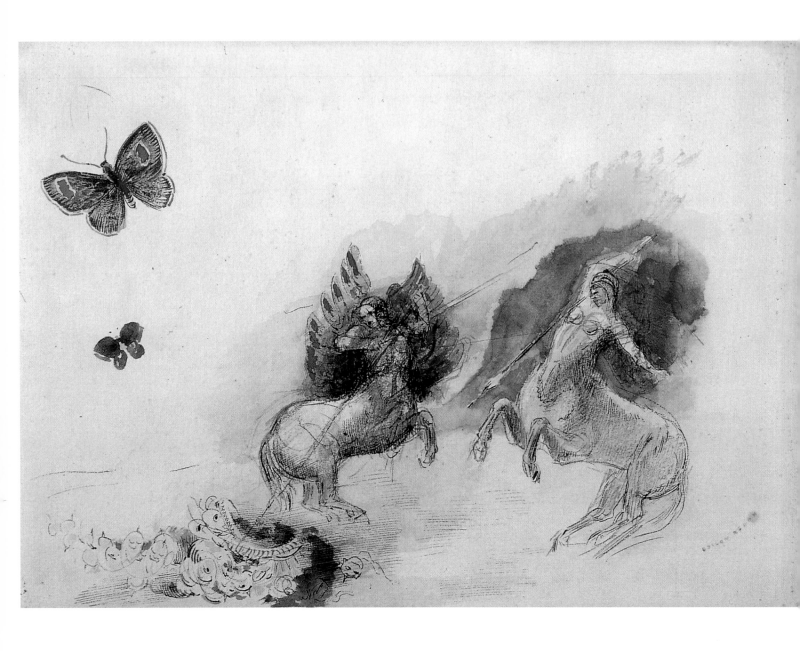

Battle of Centaurs
Lutte des Centaures
Watercolour, pen and Indian ink on paper,
17.7 x 25.6 cm
New York, The Ian Woodner Family
Collection

ful, now speculative ruminations. But the artist had no desire to produce 'literary' work: "What are the limits of the literary idea in painting?" he asks. "We are agreed. A literary notion is present wherever formal invention is lacking." And, as we have said, it is Redon's 'formal invention', which cultivates ambiguity and the indefinite, putting to good use a certain awkwardness of handling, that makes his subjects come alive. It was this twofold aspect of his work that struck Pierre Bonnard: "I have the greatest admiration for Odilon Redon. What strikes me above all is the conjunction in his work of two almost contradictory qualities: the very pure formal substance and a very mysterious expressivity." And he adds: "The man is full of benevolence and compassion. Our entire generation is under his spell and follows his advice" ("Hommage à Redon", *La Vie*, 1912, quoted in Catalogue *Donation Arï Redon*, p.6).

Redon's weak points are also significant. One of them is the expressions of some of his imaginary creatures – their features can be insipid. In contrast, his portraits, such as those of Jeanne Roberte (ill. p.19), his son Arï

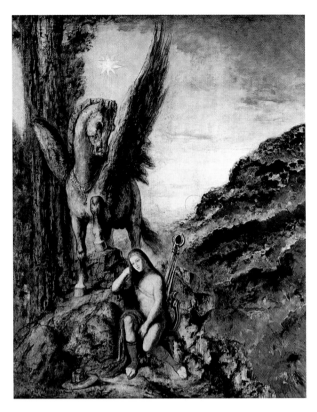

Gustave Moreau: ***The Wandering Poet***, c. 1868
Le Poète voyageur
Oil on canvas, 180 x 146 cm
Paris, Musée Gustave Moreau
Pegasus, the winged horse, is the allegorical
mount of the poet's flights of inspiration.
Redon's characteristically indistinct outline
contrasts with Moreau's treatment, allowing
free rein to the spectator's imagination.

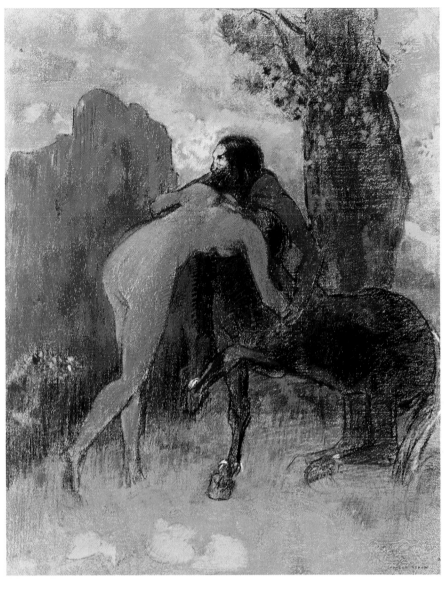

Struggle between Woman and Centaur
Lutte de la Femme et du Centaure
Pastel, 58.2 cm x 46.7 cm
Private collection

(ill. p. 18) or his artistic friends Edouard Vuillard (1868–1940), Pierre Bonnard (1867–1947), Paul Sérusier (1864–1927), Maurice Denis (1870–1943), painted around the turn of the century, or the beautiful portraits of women he subsequently produced in pastel, all have highly eloquent features.

This inspidity is perhaps what he had in mind when he declared "I owe to my country origins those sad faces that you know, and which I drew because I saw them and because the eyes of my childhood had preserved them in the inmost harmonies of my soul". But the weakness is also due to the fact that Redon's imagination was more taken with basic emotions (fear, sorrow, surprise, wonder) than with traits of character. The artist's real concern touches upon profound, 'metaphysical' issues which relate to the sense of anxiety and wonder of early childhood. For the same reason one can hardly make out the features of the figures in his most successful imaginary works. They are essentially indistinct, as in his charcoal *Diogenes* of 1888, or his *Haloed Virgin*, a pastel of 1898.

From the the early 1890s, Redon's art began to move in an entirely new direction. In a letter to Emile Bernard on 14 April 1895, he takes stock of his situation, acknowledging the extreme emotional demands made by such works: "It is true that I am increasingly forsaking black. Between ourselves, it exhausted me; I believe it springs from the depths of our being. It is, all told, the most essential colour, is it not? After making certain drawings (imperfect, it is true), I have felt as I might after some debauch..." (Catalogue *Donation Arï Redon*, p. 52).

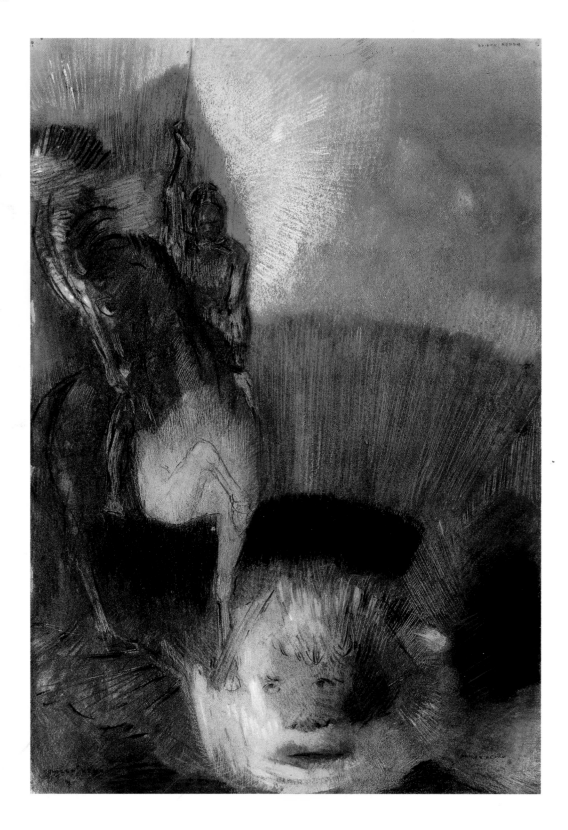

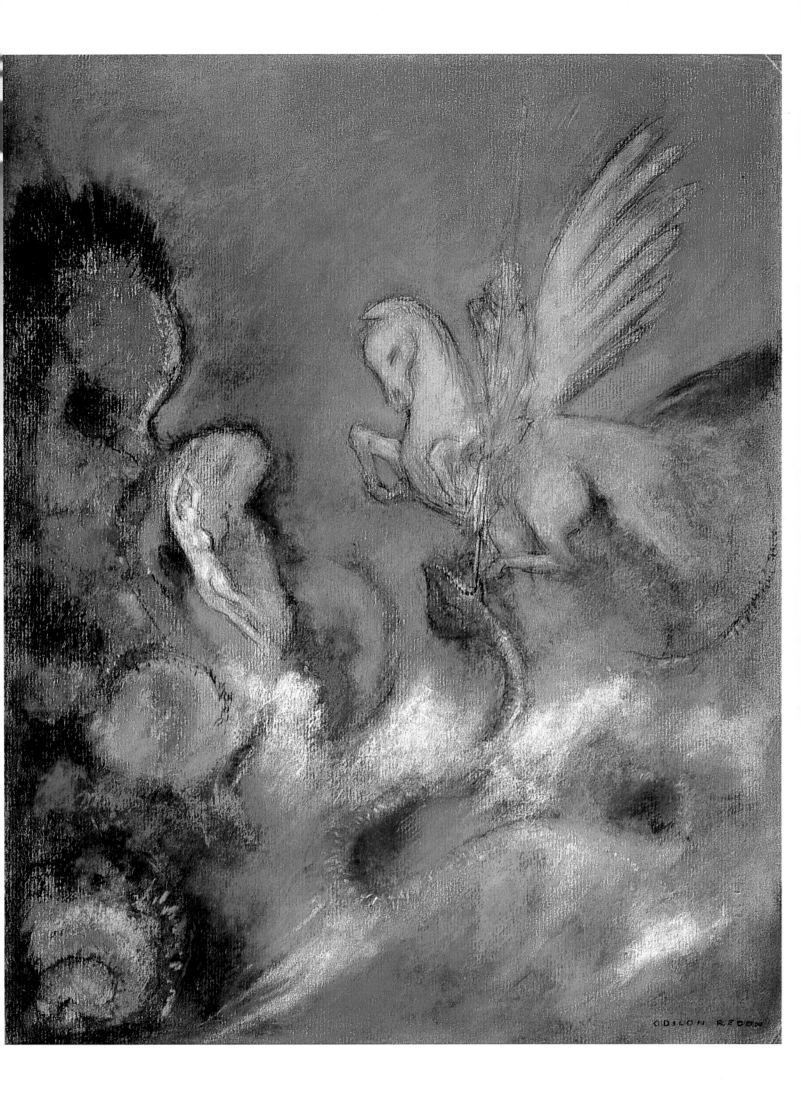

RIGHT:
Phaethon
Phaéton
Pastel, 66 x 94 cm
USA, Private collection

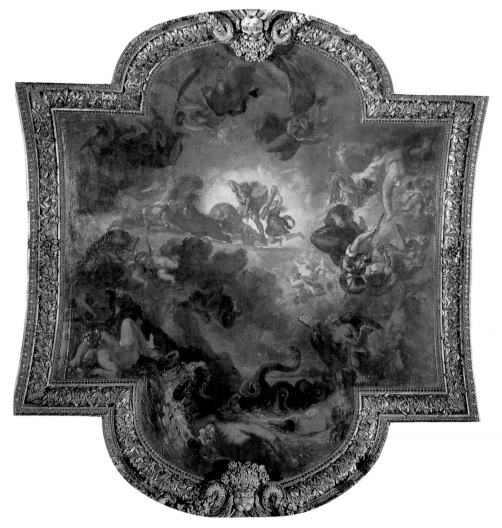

LEFT:

<u>Eugène Delacroix:</u> ***Apollo Crushing the Pythian Serpent***
Apollon terrassant le serpent Python
Oil on backed canvas, 800 x 750 cm
Paris, Musée du Louvre, ceiling of the
Galerie d'Apollon
"It is the triumph of light over darkness. It is
the joy of daylight contrasted with the sadness
of night and shadows." Redon returned awe-
struck from his first view of Delacroix's work
and noted his reaction thus. He later treated
the same theme himself, on each occasion
reducing it to the essential: chariot, horses,
serpent, god.

PAGE 69:
The Chariot of Apollo, 1905–1914
Le Char d'Apollon
Oil embellished with pastel on canvas,
91.5 x 77 cm
Paris, Musée d'Orsay

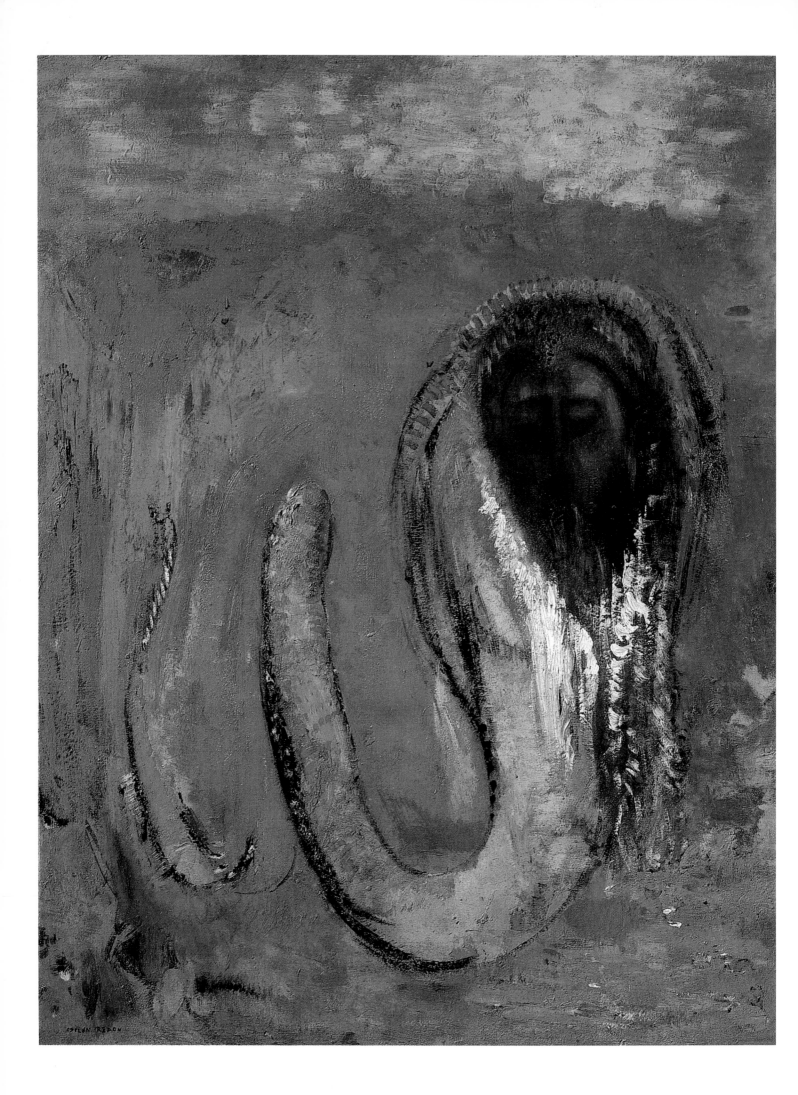

The Light

With my eyes more widely opened upon things, I learnt how the life that we unfold can also reveal joy.

Odilon Redon

A fundamental change occurred in the 1890s. The artist was then moving into his fifties; three years earlier his first child, born after seven years of marriage, had died at the age of six months. Redon wrote some poignantly self-revealing pages about the emotional bonds created by fatherhood. We remember that his marriage, in his own words, had been founded on "a certainty even more complete than my vocation." Now, with the birth of his second child, Arï, on 30 April 1889, two and a half years of mourning were dispelled. "It is too beautiful!" Redon wrote to his mother. The exclamation suggests how anxious he was; but when, in October, the vital first six months had passed, his fears began to subside. The event took on a greater significance because his own early childhood had been marked by emotional desolation, and the confirmation that a child alone can bestow had been slow in coming. We have the artist's own word for the considerable impact it was to have on his personal and artistic development.

The black period had allowed Redon to clear his accounts with the past. The art by which he had done so remained for others to enjoy, but it had been a sombre *œuvre*. Was he willing to bestow upon his newborn child this alien heritage of private anguish? Apparently not. For there suddenly appears in his work a quite unprecedented ferment of colour and of light; the pastels in which it appeared were to become his main medium. "The life that we unfold", he was later to observe, "can also reveal joy."

There are times when Redon surprises one by the simple aptness of his language. A case in point is the expression "the life we unfold" (rather than the more commonplace "life we live"). It implies that a creative activity is manifest in life itself, in the sometimes unexpected way in which a personality develops; this, he seems to say, is the condition of individual fulfilment. It is at all events clear that Redon's art underwent a fundamental change at this point. He turned to pastel and promptly began to create new and radiant visions. His art was revitalized. An important factor in this transmutation was his own fatherly affection, which Redon described as "the very creation of the child: it is his prize, his conquest, his triumph."

Emblematic of this unexpected transformation are the 'chariots of the sun', of which Redon painted many. He first remarked on their significance in 1878, when discussing the large painting Delacroix had executed for the ceiling of the *Galerie d'Apollon* in the Louvre. The work deeply impressed

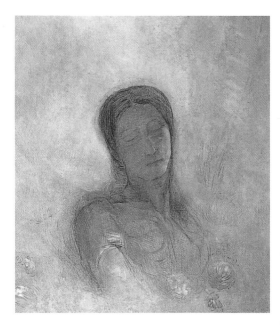

Closed Eyes, c. 1913
Les Yeux clos
Oil on paper, 53 x 48 cm
Private collection

PAGE 70:
Oannes or *Christ and Serpent*, 1907
Oannès, dit aussi Christ et Serpent
Oil on wood, 65 x 50 cm
New York, The Ian Woodner Family
Collection
Oannes, half-man, half-fish, appears not only in the lithographs but in several later works. Redon came across him in Flaubert's *The Temptation of Saint Anthony*, a sort of *Bouvard and Pécuchet* of ancient religions. In Flaubert's work, Oannes makes St Anthony laugh; he responds with the plaintive demand "Respect me! I am coeval with the origins."

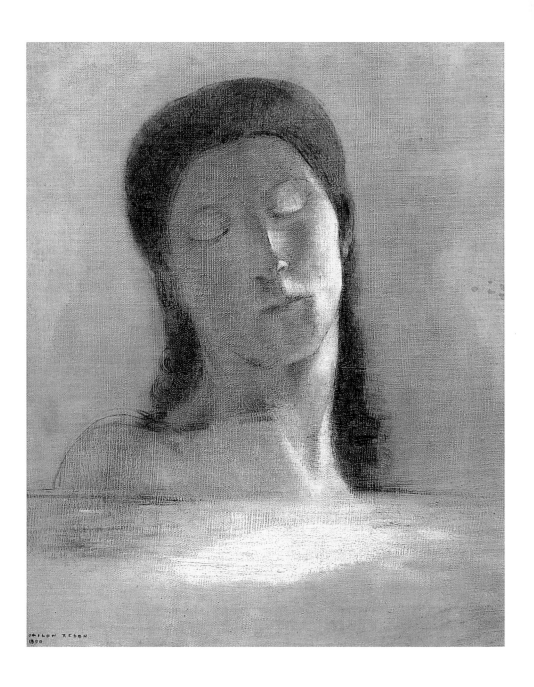

Closed Eyes, 1890
Les Yeux clos
Oil on carboard-backed canvas, 44 x 36 cm
Paris, Musée d'Orsay
This was the first of Redon's works to be acquired by the French state, and the event had a symbolic value for the painter who felt that his country had at last acknowledged him: "This is a piece of news that makes me rejoice… for those faithful few who supported me through thick and thin."

PAGE 73:
Closed Eyes
Les Yeux clos
Pencil, 35.7 x 26.1 cm
New York, The Ian Woodner Family Collection

him: "It is the triumph of light over darkness. It is the joy of daylight contrasted with the sadness of night and shadows". Eugène Delacroix had painted the chariot, horses and serpent surrounded by a multitude of other figures. Of these, Redon had no need; the economy of means exemplifies his modernity.

The transformation in Redon's art would not be convincing if it had been the product of an act of will. But the dazzling change he underwent during the last decade of the century was inward: both simple and profound. The causes were, perhaps, more complex and diverse than I have suggested. A comparison drawn from music (which played such an important part in Redon's life) may make this clear. The music of Gustav Mahler (1860–1911) is always more abundantly inventive (and thus more affecting) when it expresses anguish, sorrow and distress. Yet there are moments when the composer seems to think it appropriate to conclude a symphony on a positive and triumphant note. At such moments, critics have noted, 'his voice cracks'.

Not so with Redon. His work continued to flow out of him. In his quest for perfection of form, his fluency remained even as he sought to replicate

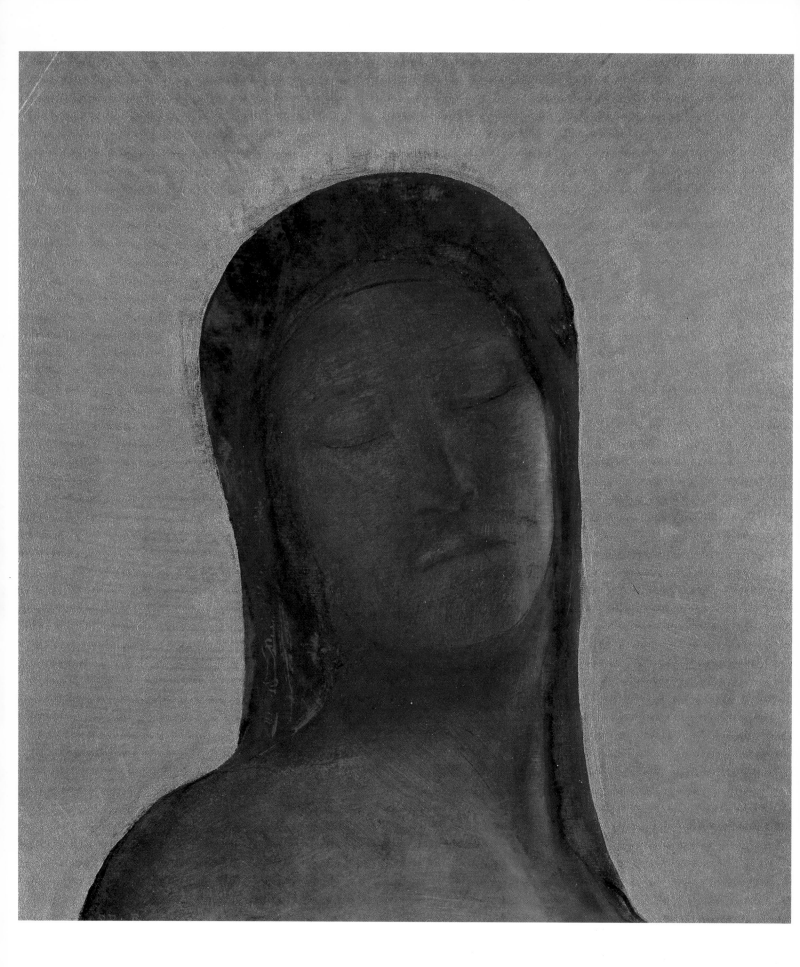

Closed Eyes
Les Yeux clos
Oil on board (with gold ground),
30.5 x 28.5 cm
Private collection

74

PAGE 75:
Closed Eyes, c. 1894
Les Yeux clos
Oil on wood, 45.5 x 36.5 cm
Tokyo, Gallery Fujikawa

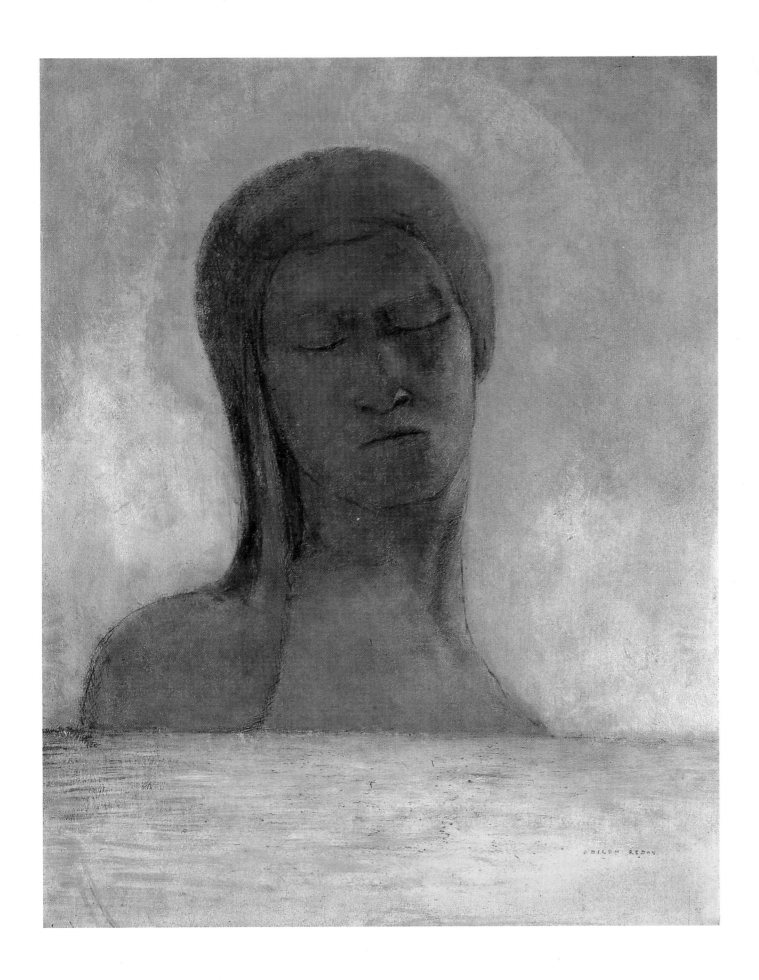

These heads have a clearly androgynous aspect, like Leonardo's *Saint John the Baptist*. The formal treatment, with the *sfumato* background and the delicately sculpted face, also owes something to Leonardo. In two versions, there is a flat surface in the foreground which suggests a stretch of water from which the giant head emerges. Redon's injunction to "do as nature does: create diamonds, gold, sapphires, agates, precious metal, silk, flesh" seems particularly applicable to the several *Closed Eyes* with their different tonalities.

in the new medium of pastel the mastery of chiaroscuro he had gained in charcoal. He once told André Bonger: "My entire art is confined to the resources of *chiaroscuro;* it also owes a great deal to the effects of abstract line, which acts directly upon the spirit as the agent of deepest inspiration."

Two somewhat contradictory observations may serve to cast some light on the turning-point in Redon's work. "Painting", he wrote in 1905, "means confirming a special meaning, an inborn significance, so that a rich substance can emerge, in the same way that nature creates diamonds, gold, sapphires, agate, precious metals, silk and flesh. One is born with the gift of sensuality; it cannot be acquired." This is the voice of Redon clearly rejoicing in the liberated sensuality of his late work, a sensuality which was to illuminate the last twenty-five years of his life. However, a few years later, while he was lecturing in Holland, he declared that black "is the most essential colour... Black should be respected. Nothing prostitutes it. It neither pleases the eye nor awakens sensuality".

This prompts us to take a closer look at the way we perceive colour. Night, as we know, is colourless. In darkness we only make out shapes and silhouettes, and all the resources of our mind are devoted to identifying them. The retinal cells that are sensitive to colour take no part in this. One might say that night is a time of apprehension and 'prehension', of attention and analysis. We rarely dream in colour but move through our dreams as if through some inner night. Though most dreams derive from an emotional nucleus, the dreamer struggles to understand and master their unfolding.

Daylight alone allows us to see colour. In daylight, colour assuages our senses, speaking to the emotions directly and without intermediary. Colour, like smell, bypasses thought and impacts directly upon the emotions. A blend of scents, a juxtaposition of colours can make the heart leap while the analytic powers, so vigorous in the dark, are short-circuited. One might also contrast the 'daylight' instrumental tones of music with its more 'nocturnal' structures. Tone quality – the blending of instruments which lends music its true, intangible materiality – also touches us at a prelinguistic level.

Redon's work between 1890 and 1916 led him to shimmering juxtapositions of colour. His finest work effortlessly communicates a sense of space, freedom, and weightlessness. Above all, it delights, and the sense of delight transfigures everything, driving out the old demons.

There were, however, other factors that played a part in this transition. We should take into account the artist's deepest conviction, as he expressed it in a little text written in 1908: "A painter who has found his technique is of no interest to me. He gets up in the morning without passion, and he quietly and peacefully continues with the work he started the day before. I suspect he feels much the same kind of boredom as that experienced by a conscientous worker who goes about his duties without any unexpected moment of happiness to light his day. He does not suffer the sacred torment that rises from the subconscious and the unknown; he expects nothing of that which is to come. I love what never was". This love of "what never was" goes to the very heart of Redon's creative powers; he could paint only "according to [himself]."

It seems that the artist went through a spiritual crisis during this period. He was approaching sixty having, as Roseline Bacou points out, spent his life as a witness to rather than an actor in the major artistic events of his day. True, he was admired by a number of artists and poets whose opinion was respected, but there had been no breakthrough. And the events of his

Bust of a Man Asleep amid Flowers
Buste d'un homme endormi parmi les fleurs
Black crayon and watercolour, 25.5 x 17.7 cm
Paris, Musée du Louvre

life seemed to follow an underlying pattern of 'death and resurrection'. 'Abandoned' as a child, he was 'accepted' in marriage; his first-born's death was followed by a resurrection of sorts in the birth and survival of his second child. From Redon's sensibility as revealed in his writings, it would seem that these are some of the factors (with others which we cannot know) that brought about his dazzling and belated transformation: his emergence into daylight.

The transition was gradual. It began with the giant figure in *Closed Eyes* (1890, ill. p. 72), a work – exceptionally – dated by the artist. The head seems to rise out of the sea, filling the horizon. Certain critics see in this figure the features of Madame Redon, but the nose is different from those in the portraits of the artist's wife, and the face and neck are of undeniably masculine proportions – even though the overall effect is as androgynous as that of Leonardo da Vinci's *Saint John the Baptist*. From a formal point of view, incidentally, (the *sfumato* of the background and the delicate modelling of the face,) the whole work owes something to Leonardo. The colour here is still subdued; Redon later described the work as "a bit grey", but it represents a crucial step in the artist's move towards colour.

One might be tempted to see in this figure rising from the waters of death into a grey dawn a Christ-like image of the resurrection. The figure emerges, but the eyes are closed; we remain in suspense. A variant of this work, also 1894 (ill. p. 75), accentuates the Christ-like aspect of the head by surrounding it with a halo. The foreground of the second painting, of more summary execution for the most part, does not suggest water, and we are reminded that Redon, in several of his portraits, placed a neutral horizontal strip in the foreground to mark, as it were, a separation. If we are tempted to recognize a watery surface in the foreground of the work above, it is because Redon's treatment here is different, suggesting a horizontal plane in which the head is reflected.

About this time, explicitly Christian figures occur: Christ, the Virgin, the Holy Women. One such is the *Christ of Silence*, which might almost be a sequel to *Closed Eyes*. Redon treats Christian images in much the same way as he does the Buddha (whom he represented in several superlative pastels) and other religious figures: as though they signified a universal urge toward salvation. It is a salvation through which life's meaning is unveiled and serenity is won.

Similarly, one might interpret the numerous pastels of women in boats as images of a voyage of initiation, where life itself is an initiation accomplished via "the slings and arrows of outrageous fortune". The voyages may even be an allusion to the artist's wish to have been born on the open sea, in "a place without a homeland, over an abyss." The father who rather frightened him is no longer present; the vessel holds one woman, or two at most. And Redon, "already conceived and close to being born", accompanies them, as the golden sail carries them off toward the land of Cockayne.

The Mystic Boat, a pastel of uncertain date (c. 1890–1895, ill. p. 29), is one of Redon's masterpieces; its formal simplicity and the intensity of the colours makes reproducing it a hazardous undertaking. The bright blue vessel, borne over green waters, sails beneath a sky dappled with gold and silver. The bright yellow of the sail sets off the blue of the hull, fascinating the eye. Indeed, it is tempting to perceive in this a vision from the early years of the artist's life: a reminiscence of those days in which the tiniest details stand out with hallucinatory intensity, filling the child's eye with pro-

Woman with a Veil, c. 1895–1899
Femme voilée
Pastel, 47.5 x 32 cm
Otterlo, Rijksmuseum Kröller-Müller

found happiness. Several other pastels – *Woman in a Boat* (1897), *Haloed Virgin*, (c. 1898), *Holy Woman in a Boat* (c. 1900), *Two Lovers in a Boat* (1902, ill. p. 28) – are variations on this theme.

Redon described his *Haloed Virgin* in the following terms: "A dark brown sky with violet and red clouds; to the left, a haloed figure in a barque, sheaves of gold on the prow of the barque, and on the waters a sort of blue phosphorescence, like a will-o'-the-wisp" (quoted by R. Bacou, cat. 1956–1957, No. 76). The "sheaves of gold" are rather ambiguously drawn (a chain, brambles, a mooring rope?), like the thorns encountered in other pastels of the period, for instance, *Rêverie* (1900–1905).

Having once used colour, Redon would never turn back: "I wanted to do a charcoal drawing, as I had in the past", Redon wrote to Maurice Fabre in 1902. "It turned out to be impossible; I have broken with charcoal. When it comes down to it, only new matter allows us to renew ourselves… I have espoused colour…" (Lettres, p. 50).

In the last two decades of the century Redon got to know Paul Gauguin. They met at an exhibition in 1886, and their letters testify to their mutual esteem: "You are a true artist (though unfortunately you do not have the esteem you deserve)", Gauguin declared (in a letter quoted by R. Bacou, 1956, p. 185). There is something comical about Redon, who could never be parted from his wife and child, exclaiming on Gauguin's departure for Tahiti: "What a splendid life! and what an example! in order to be able to paint in the open air and in a beautiful light, he has abandoned his wife and four children!" (quoted in the Bordeaux catalogue, 1985, p. 145). On this point Vincent van Gogh (1853–1890) was closer to Gauguin and closer to the truth. He wrote to his brother Theo: "Physically he [Gauguin] is stronger than we are; his passions too, must be stronger than our own. First he has children, then he has his wife and family in Denmark; at the same

Anonymous: *Théâtre des Menus-Plaisirs: The Invisible*
Poster for a showing of projected microscope enlargements, 1883
Colour lithograph
Ottawa, National Gallery of Canada
The botanist Armand Clavaud showed the enthusiastic Redon the shimmering world of the infinitely small through his microscope, an instrument not then widely diffused. The poster is in amusing contrast with the luminous colours of Redon's work.

PAGE 80:
Beasts of the Sea-floor or *Marine Monsters*
Bêtes au fond de la mer, dit aussi Monstres marins
Pastel, 60 x 49.4 cm
New Orleans (LA), The New Orleans Museum of Art

Underwater Vision, c. 1910
Vision sous-marine
Oil on canvas, 166 x 96 cm
France, Private collection

time, he wants to go to the ends of the earth, to Martinique. The conflict of desires and incompatible needs which all this must generate in him is dreadful…".

In September 1890, before sailing to Tahiti (and not Martinique as Van Gogh had initially thought), Gauguin wrote to Redon, citing Wagner: "I believe", the composer had written, "that the disciples of high art will be glorified; robed in a celestial weave of rays, perfumes and melodious chords, they will return and lose themselves forever in the bosom of the divine source of all harmony." "And so, my dear Redon," Gauguin concluded, "we shall meet again." Gauguin died on 8 May 1903 in the Marquesas, and

that same year Redon, much affected by his death, painted a posthumous portrait of the artist he admired – *The Black Profile, Gauguin*. In it the profile of the self-proclaimed 'savage' – the aquiline nose of which Gauguin was quite proud (and which he liked to accentuate in self-portraits, depicting himself as 'harder' than he actually was) – has been softened and endowed with an almost feminine mildness.

Mythology occupies an important place in Redon's later work. We again encounter the *Chariot of the Sun* and *Pegasus*, the winged steed of the poets. But *Pegasus* is no longer captive, his wing is no longer 'impotent' (as in the first series of lithographs); we see him pawing the ground as he prepares to

Mysteries of the Sea, c. 1903
Mystères de la mer
Oil on canvas, 35.5 x 24 cm
Tokyo, Art Point Gallery

Flowers, Red Panel, 1906
Fleurs, panneau rouge
Tempera on canvas, 159.5 x 113.5 cm
Paris, Private collection

PAGE 85:
Sleeping Cat
Le Chat endormi
Oil on canvas, 54.9 x 38.5 cm
Private collection

take flight from a mountain top (in a pastel executed about 1900, ill. p. 62), or spreading his large green wings as he tramples a dragon (oil on cardboard, 1907).

The serpent also returns under various forms. A rather unusual oil of around 1907 is (perhaps mistakenly) entitled *Oannes or Christ and Serpent* (ill. p. 70). It resembles Redon's paintings and lithographs of the Chaldean divinity, Oannes – a human head on the body of a fish. Here the head is attached to the green rings of a huge snake, and the scope for interpretation is considerable. Commentators invoke Redon's interest in Hindu thought, in which "good and evil are intimately connected and not antithetical" (Bordeaux Cat. 1985, p. 168). But one might equally invoke the Talmudic tradition which ascribes the same numerical value to the word *Meshiah* as to the Hebrew word for 'serpent'. One may further note that, in this myth, the serpent sets time in motion, while the Second Coming of the Messiah is expected to end it.

This mode of representation is of interest because it suggests the fertile and as yet unconceptualized myths which underlie every culture and which works of art unwittingly present. 'Unwittingly' because any work of art is shaped partly by the broader dream of the community, and the latter, in its turn, commands the way each of us perceives the world and understands good and evil. We cannot claim to know Redon's opinion of this. As we have seen, he favoured the indefinite and indeterminate. Nothing else could, in his view, stimulate thought.

During the last fifteen years of his life Redon executed large-scale decorations for private residences: in Paris in the home of the composer Ernest

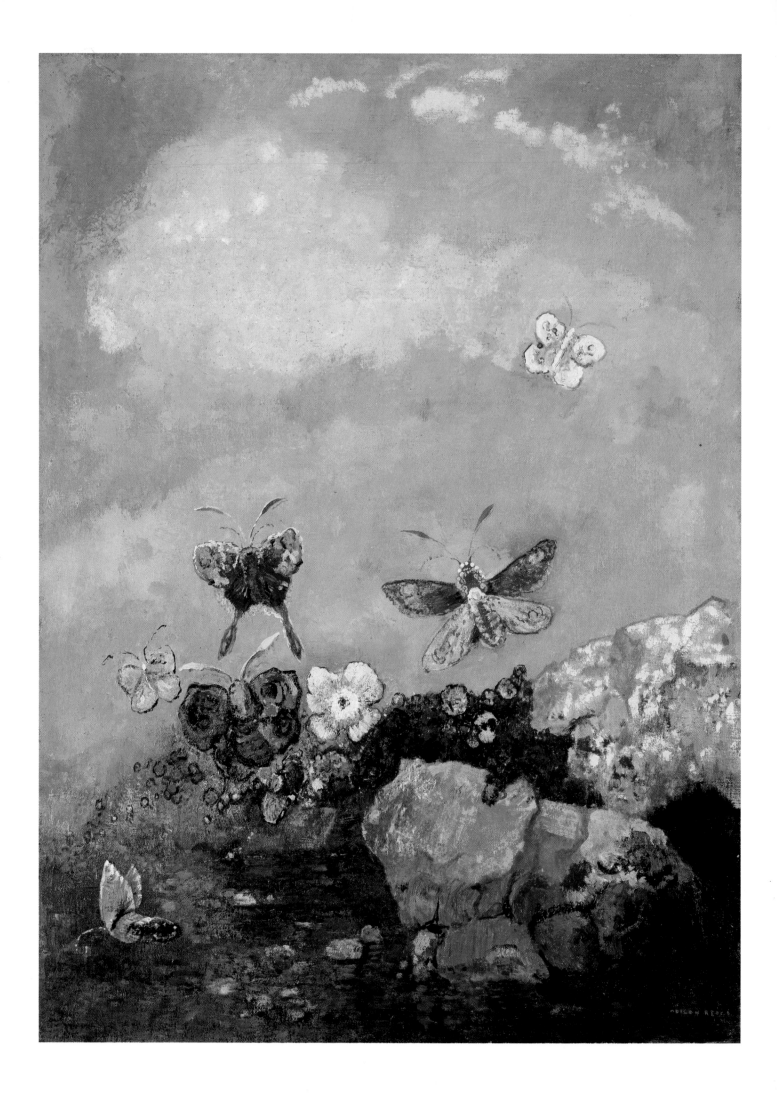

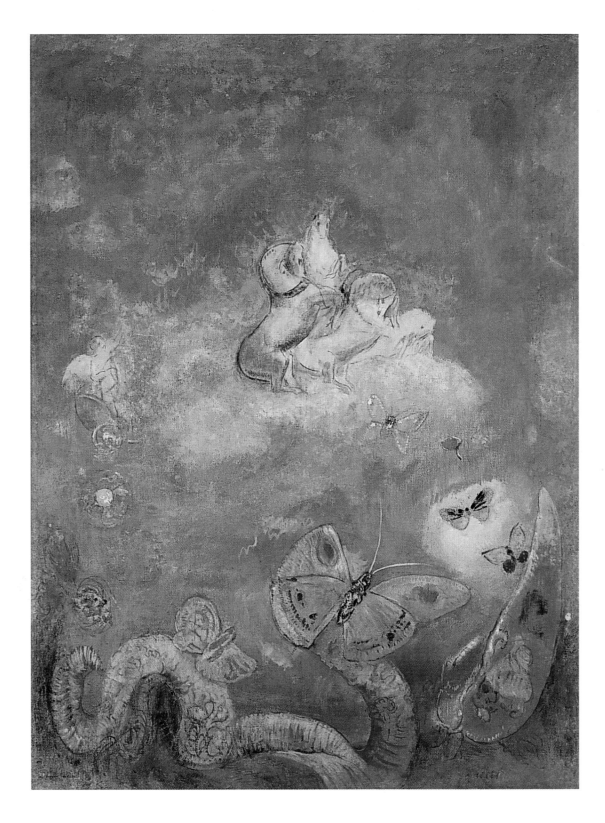

Chausson (1901); in the home of Robert de Domecy at Domecy in Burgundy (1902); and at the home of Gustave Fayet, Fontfroide Abbey, in the Aude (1910). He wrote to André Bonger on 17 January 1901: "I am covering the walls of a dining room with flowers, dream flowers and imaginary beasts: all of this on large panels, and working with a bit of everything, tempera, aoline, oil and even pastel… Where are my *Noirs* now?" (Letters, pp. 43–44). These commissions were on quite a new scale for Redon, who had almost always favoured a modest format. They allowed him to work out a decorative format that never tips over into abstraction, but in which the real and imaginary flowers and plant forms – always recognizable as such – are somehow light, airy and dazzlingly luminous.

The Chariot of Apollo, 1912
Le Char d'Apollon
Oil on canvas, 100 x 74.7 cm
New York, The Ian Woodner Family Collection

PAGE 86:
Butterflies
Papillons
Oil on canvas, 72.5 x 53 cm
New York, The Museum of Modern Art

ODILON REDON

During the final years the oils and especially the large pastels became increasingly iridescent, as though designed to surprise the eye and rejoice the heart. The monsters are transfigured: *The Cyclop* of the 1898–1900 painting (ill. p. 45) becomes a gentle supplicant who rises above a richly coloured landscape, petrified with admiration in the presence of a female nude. And one wonders, remembering the theme of the single eye in Redon's work, whether the Cyclops does not stand for the artist himself: he whose eye had first been lifted to the "marvellous clouds" of Baudelaire's celebrated prose poem, then plunged into contemplation of the shadows, before returning to the daylight aspect of the world and finding in it abundant consolation.

The paintings of the last years were often very free in form, entirely devoted to the interplay of colour and to sometimes unexpected associations of forms. *Homage to Leonardo da Vinci* (1908), with its reminiscences of the Italian master, and the oil-paintings *Mysteries of the Sea* (c. 1903, ill. p. 83) and *Underwater Vision* (c. 1910, ill. p. 82) fit this description. The last of these reveals a highly musical form consonant with the spirit of the age, and carries Redon's manner to its logical conclusion. The first decade of the 20th century is already the age of Futurism, of Cubism: of the *Demoiselles d'Avignon*. We find no trace of all this in Redon. Here, on the contrary, everything is shimmering light and ecstatic mastery of radiant colour.

The transfiguration in Redon's work is perhaps best illustrated by *The Chariot of Apollo* (ill. p. 87) in the Woodner Collection (1902). Here the redoubtable dragon has become a large, blind, pink worm, writhing on a lawn over which butterflies gambol; Redon seems to suggest that his size is just a matter of our proximity. But up there, in the light which lends the butterflies their colours, the horses of the sun triumphantly paw the air, never weary of propagating the light.

This is an appropriate image on which to conclude, for it summarizes the itinerary of Odilon Redon. Like other children of solitude, he emerged from the shadows and quietly recreated the world in his own image. But we should be careful to avoid excessive interpretation. "Every pen wants to draw me into its faith", he wrote to Edmond Picard, on 15 June 1894. "It is wrong to assume that I have goals. I make art and nothing else."

PAGE 88:
Butterflies
Papillons
Watercolour, 22 x 15 cm
Private collection
"For Redon, butterflies – like flowers – combine the symbols of youth and passing time, of beauty which fades and life which blossoms and dies." (A. Lacau St Guily – Wildenstein Institute)

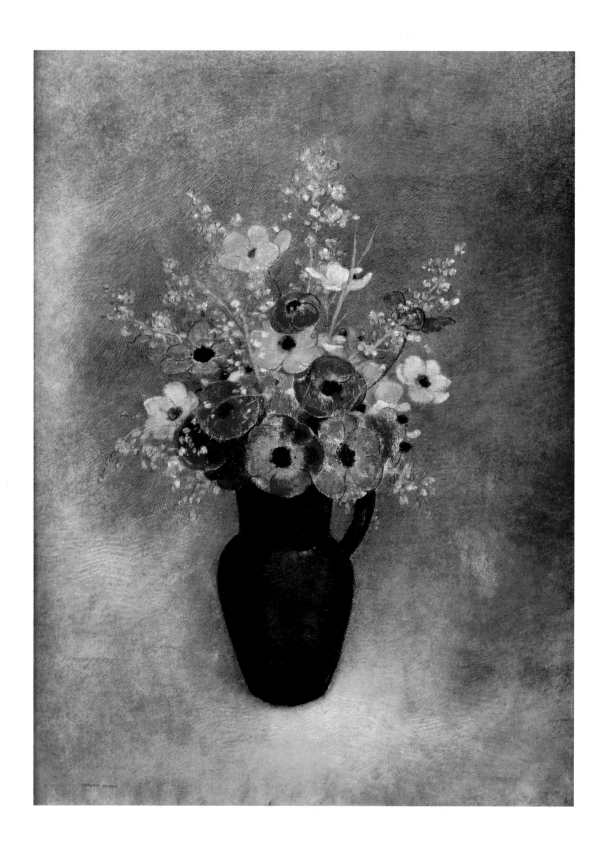

Anemones in a Jug
Anémones dans une cruche
Pastel, 39.5 x 29.5 cm
New York, The Ian Woodner Family
Collection

PAGE 91:
Vase of Flowers
Fleurs dans un vase
Oil on canvas, 71 x 38.5 cm
New York, The Ian Woodner Family
Collection

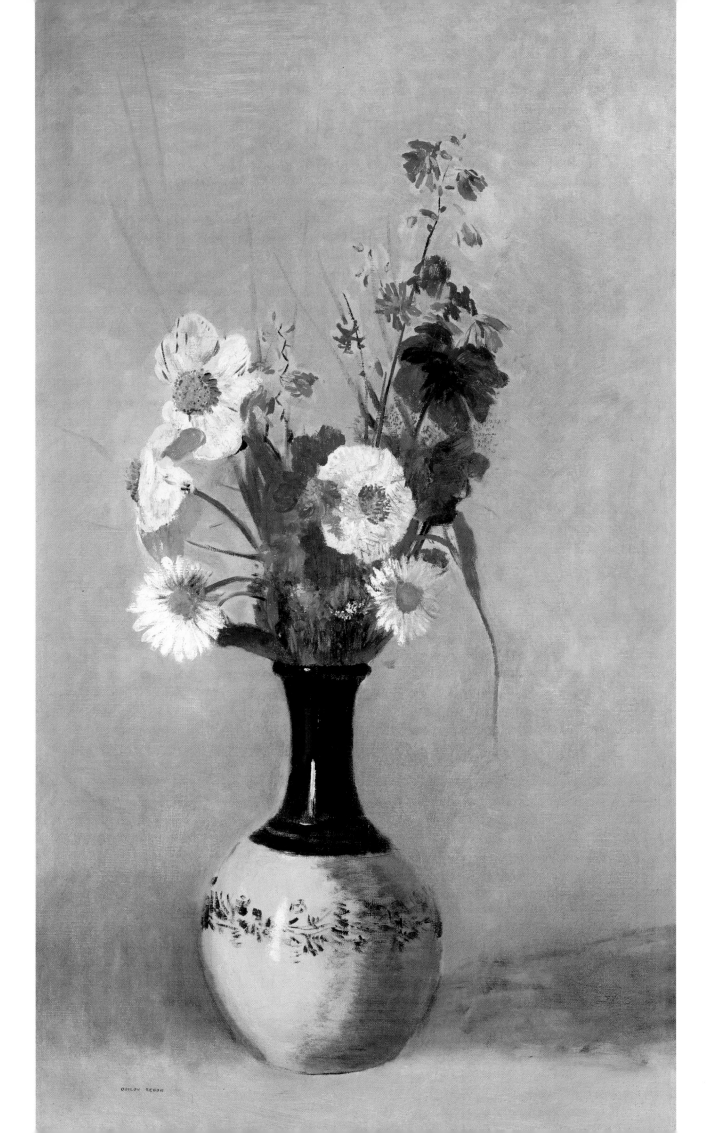

Odilon Redon: Life and Work

BOTTOM:

<u>Edouard Vuillard:</u> ***Portrait of Odilon Redon***
(detail), 1901
Portrait d'Odilon Redon
Oil on canvas, 33 x 27 cm
Paris, Musée du Louvre

RIGHT:

Redon's various signatures are taken from the first page of volume 1 of the *Catalogue raisonné* of the work of Odilon Redon, established and published by the Wildenstein Institute in 1992.

1840 Redon, second son of Bertrand Redon and Marie-Odile Guérin, is born on 20 April at 24 rue Neuve Saint-Seurin (now 31 rue Fernand-Marin), Bordeaux as Jean-Bertrand Redon (known as Odilon). Shortly afterwards, the family moves to 26 allées Damour, where Redon believed that he was born; he spelt it *allées d'Amour*.

1840–1851 Odilon, entrusted to the care of his uncle, spends his childhood on the family estate in Peyrelebade in the South of France.

1851 Joins his parents in Bordeaux and is sent to school.

1855 Takes drawing lessons with the water-colourist Stanislas Gorin.

1857 At his father's behest, Redon studies architecture. Attempts to enrol for architecture at the Ecole des Beaux-Arts in Paris, but fails the oral entrance examination. He becomes friends with the botanist Armand Clavaud who helps him discover the literature of his day and teaches him botany and the rudiments of natural science and gives him an account of evolutionary theory.

1859 Travels to Uhart in the Pyrenees with his friend Henri Berdoly.

1864 Practices sculpture in Bordeaux. Attends Gérôme's *atelier libre* at the Paris Beaux-Arts. Incompatibility between master and pupil makes this a painful episode for Redon.

Self-Portrait, c. 1880
Autoportrait
Oil on canvas, 46.4 x 33.3 cm
Paris, Musée d'Orsay

Portrait of Camille, Madame Odilon Redon
(detail), 1882
Portrait de Camille, Madame Odilon Redon
Oil on canvas, 45.5 x 37.5 cm
Paris, Musée d'Orsay

1865 Back in Bordeaux, Redon meets Rudolphe Bresdin who teaches him etching and lithography.

1867 His *Roland at Roncevaux* is accepted by the Salon but Redon chooses not to exhibit it. Publishes an account of the Salon in *La Gironde* in which he defines his attitude towards contemporary trends.

1868 Spends the summer in Barbizon; meets Camille Corot.

1870 His friend the architect, Carré, commissions him to decorate a chapel in Arras. He takes part in the war against Prussia as an enlisted volunteer and is involved in action on the Loire.

1872 Redon moves to Paris. He returns to Peyrelebade every summer. He is a frequent guest at Madame de Rayssac's literary and musical salon, where he meets Fantin-Latour, Chevanard and, some years later, his future wife, Camille Falte.

1873–1877 Studio at 81 Boulevard Montparnasse. Beginning of his great creative period. Works almost exclusively with charcoal and lithography – *les Noirs* ('black' works).

1874 When his father, Bertrand Redon, dies, the family runs into financial difficulties.

1875 During the spring, makes studies of trees and undergrowth at Barbizon. Trip to Brittany in July.

1878 Travels to Belgium and Holland. Admires Rembrandt.

1879 Publishes his first album of lithographs, entitled *In Dream*.

1880 On 1 May marries Camille Falte, a young woman of creole descent from Ile-Bourbon.

1881 Exhibition of charcoal drawings at *La Vie Moderne*.

1882 Exhibits charcoal drawings at *Le Gaulois*. Publishes the album entitled *To Edgar Poe*. Meets Joris-Karl Huysmans and Emile Hennequin who introduces him to Stéphane Mallarmé the following year.

1883 Publishes the album entitled *Les origines*. Beginning of his friendship with Stéphane Mallarmé.

1884 Death of his brother Léo. Redon takes part in organizing the first *Salon des Indépendants* of which he was later President, then Vice-President. Huysmans publishes his novel, *A Rebours* in which he describes works by Redon.

1885 Publishes the album entitled *Hommage à Goya*. Death of his sister Marie. Death of Bresdin.

1886 His first son, Jean, born 11 May, dies 27 November.
Album entitled *La Nuit*. Exhibits with Gauguin at the *Salon des XX* in Brussels.

1887 Illustrations for Edmond Picard's *Le Juré*. Frontispiece for Emile Verhaeren's *Les Soirs*. Works with Fantin-Latour for *La Revue Wagnérienne*.

1888 Publishes the album entitled *The Temptation of Saint Anthony*. Foundation of the group of painters called the Nabis.

1889 Publishes the album entitled *To Gustave Flaubert*.
Takes part in the first Painters-Engravers' Exhibition at Durand-Ruel's. Meets André Mellerio, his future biographer, who later introduces him to Maurice Denis. His son Arï is born on 30 April.

1890 In February, travels to Brussels with Mallarmé. Publishes the album entitled *Les Fleurs du Mal*. Begins working in pastel. Paints *Closed Eyes*. On 1 December, his friend Armand Clavaud commits suicide. Closer contacts with Gauguin.

1891 Publishes the album entitled *The Dreams*, dedicated to the memory of Armand Clavaud. Jules Destrées publishes *L'Œuvre lithographique d'Odilon Redon* in Brussels.

1894 Exhibits at Durand-Ruel's in April.

1895 Travels to London.

1896 Illustrates Bulwer-Lytton's *Haunted House*. Publishes the third of his albums on *The Temptation of Saint Anthony*.

1897 Peyrelebade having been put up for sale, Redon spends eight months there, from April to November.

1898 Exhibits at Vollard's. Spends the summer in Villa Goa at Saint-Georges-de-Didonne, to which he returns every year for some ten years.

1899 Publishes his last album, *The Apocalypse of John*. Exhibits with the Nabis at Durand-Ruel's.

1900 Travels to Italy with a patron of the arts, Robert de Domecy. Maurice Denis paints his *Hommage à Cézanne*; Redon is depicted in front of a painting by Cézanne, surrounded by Bonnard, Vuillard, Roussel, Sérusier, Denis Mellerio (Redon's first biographer) and Vollard.

1901–1902 Decorative panels for Ernest Chausson in Paris and Robert de Domecy at the Château de Domecy in Burgundy. Friendship with Gustave Fayet. Vuillard visits him at Saint-Georges-de-Didonne.

1904 An entire room at the Salon d'Automne, founded the preceding year, is devoted to the work of Redon. The Musée du Luxembourg acquires *Closed Eyes*.

1905 Moves to 129, avenue de Wagram.

1907 Organizes an auction of his works at the Hôtel Drouot in the hope of buying back Peyrelebade. Travels to Switzerland in the summer.

1908 Travels to Venice with Arthur Fontaine. Works for the Gobelins. *Homage to Bresdin* at the Salon d'Automne. Redon writes the preface.

1909 Spends the summer at Bivres.

1910 Decorates the library of Fontfroide Abbey (Aude) at the request of Gustave Fayet.

1913 Forty of his works are exhibited at the Armory Show in New York, Chicago and Boston. Marcel Duchamp's *Nude Descending a Staircase* triggers a scandal. André Mellerio publishes the catalogue of his etchings and lithographs.

1914 Last journey to Holland. Arï Redon is drafted by the army.

1916 On 6 July, Redon dies in Paris. He is buried in Bivres cemetery.

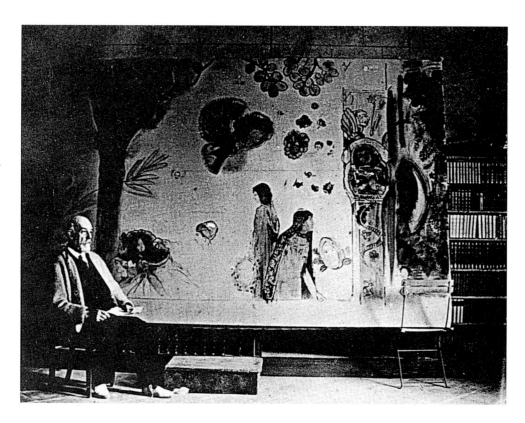

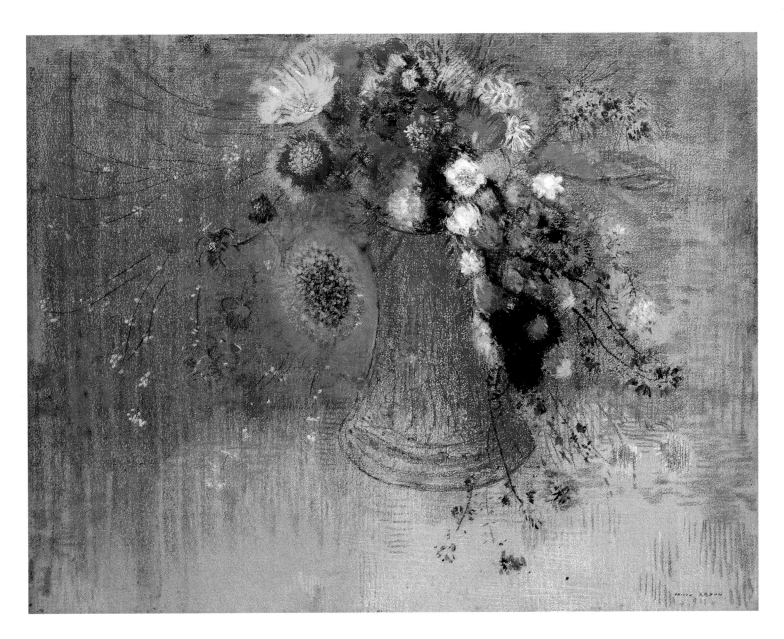

Bibliography

Bacou, Roseline: *Odilon Redon*. 2 Vols., Geneva, 1956.

Berger, Klaus: *Odilon Redon*. Cologne, 1964.

Druick, Douglas W. (ed.): *Odilon Redon* (The Art Institute of Chicago). London, 1994.

Druick, Douglas W. (ed.): *Odilon Redon. The Price of Dreams*. London, 1993.

Gibson, Michael: *Symbolism*. Cologne, 1995.

Lettres à Emile Bernard. La Rénovation esthétique. Tonnerre, 1926.

Lettres à Odilon Redon (by Gauguin, Gide, Huysmans, Jammes, Mallarmé etc.) Ed. by José Corti, Paris, 1960.

Lettres d'Odilon Redon. 1878–1916. Preface by M.-A. Leblond. Paris, Brussels, 1923.

Piel, Friedrich (ed.): *Odilon Redon 1840–1916. Meisterwerke aus der Sammlung Ian Woodner*. Exihibition Catalogue Museum Villa Stuck 17.03.–08.06.1986. Munich, 1986.

Redon, Odilon: *A soi-même. Journal 1867–1915. Notes sur la vie, l'art et les artistes*. Paris, 1961.

Redon. Texts by R. Negri and Ch. de Bellescize. Published in the series "Chef-d'œuvre de l'Art". Paris, Milan, Geneva, 1970.

Roger-Marx, Claude: *Redon. Fusains*. Paris, 1950.

Sandström, Sven: *Le monde imaginaire d'Odilon Redon*. Lund, 1955.

Selz, Jean: *Odilon Redon*. Munich, 1977.

Wildenstein, Alec: *Odilon Redon*. Catalogue raisonné de l'œuvre peint et dessiné. Vol. I: Portraits et figures. Vol. II: Mythes et légendes. Texts: Agnès Lacau St. Guily. Photos: Marie-Christine Decroocq. Paris: Wildenstein Institute 1992, 1994 (Volumes III and IV in preparation).

Wildenstein, Alec: *Odilon Redon*. Published in the series "A l'école des grands peintres", No. 21. Paris, 1982.

PAGE 94, TOP:
Self-Portrait, c. 1898
Autoportrait
Black crayon, 14 x 17.9 cm
Paris, Musée du Louvre

PAGE 94, BOTTOM:
Odilon Redon in the library of the Abbey de Fontfroide, in front of the panel *Night*, 1910

TOP:
Vase of Flowers
Vase de Fleurs
Pastel, 47 x 60.5 cm
Private collection

Acknowledgements

The author wishes to thank the Wildenstein Institute, Paris, and Marie-Christine Maufus, publications director at the Wildenstein Institute, for their most valuable assistance.

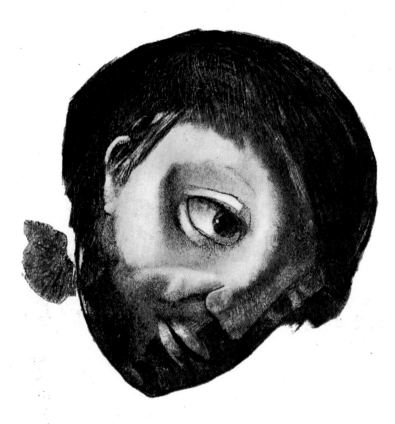

Guardian Spirit of the Waters (detail), 1878
Génie sur les eaux
Charcoal, 46.6 x 37.6 cm
Chicago, The Art Institute of Chicago